PRESERVATION OF PHOTOGR.

D1003556

Table of Contents

1

About this book...

This book is addressed to those who have charge of negatives and prints from the past. Art galleries, museums, archives, and libraries, as well as scientific, industrial, and private custodians, share similar problems in preserving photographs. In many cases there are needs to repair deterioration that has already taken place, to improve the conditions under which collections are stored, and to work with processors in order to make sure that material currently being added is properly prepared.

Since correct processing is an indispensable element in making pictures that last, this Data Book is also addressed to all who are concerned with processing. In particular, it is directed to photographers who do their own black-and-white processing or have processing done under their control. Only if today's pictures are processed properly do they have a chance of surviving into the future as a photographic record of the present.

In the preservation of photographs, there are many uncertainties, and it is not always possible to judge how long an item will last. It is known that images produced by several early processes have endured for a century and longer. Whether or not original prints on the later gelatin-silver halide papers will last as long is uncertain, especially when the conditions of preparation and storage are not known. Many prints on these papers are in excellent condition after 80 or 90 years. Many others, unfortunately, are in various stages of deterioration due to improper processing or adverse storage conditions, or both.

Today, of course, most photographs of historical, commercial, or sentimental value are being made on color materials, and there is a strong trend toward greater use of color. For these reasons, a discussion of the preservation of color images has been included,

together with the most specific recommendations deemed practical.

In recent years, concern over deterioration of photographs has spread and intensified among those who have the responsibility for preserving them. Sharing that concern, Eastman Kodak Company has brought together here the best advice it can offer on the preservation of still photographs, primarily those in black-and-white. No attempt has been made in this Data Book to cover the preservation of motion pictures and microfilms, both of which require specialized handling.

Since the chemical deterioration of black-and-white photographs is a relatively slow process, the work of preservation and restoration is not an urgent one in the sense that a specific deadline must be met. Rather, it is a question of dealing first with the oldest records, or those that show signs of deterioration, and then instituting a continuing program of inspection, followed by suitable action if it is needed. A relatively urgent situation may, however, exist with collections of early film negatives. Many such negatives are on nitrate base, which is an inherently unstable material. Negatives on nitrate base should therefore be duplicated as soon as possible.

Considering the uncertainties involved, it is only realistic to assume that a photographic image has limited life as an original. On the other hand, even partially deteriorated images can be copied and reprinted. Modern photographic materials, both black-and-white or color, make possible repeated duplication with very little loss of sharpness, detail, or tonal values. The copies can be prepared and stored under optimum conditions. Thus the life of an image and the visual information it carries can be extended indefinitely.

Structure of Photographic Materials

This section is concerned with the materials from which the majority of photographs are made, and with the effects of long-term keeping on these materials. Photographs made by very old processes, such as daguerreotypes, tintypes, ambrotypes, collodion-coated glass plates, albumenized paper, and the like, are described in an appendix.

The gelatin-silver bromide dry plates and gelatin-silver bromide or gelatin-silver chloride papers in use by the end of the nineteenth century were essentially the same as the black-and-white materials manufactured today. Consequently, most of the photographs with which the custodian of a photographic collection has to deal are made with these kinds of materials. The properties of the materials under conditions of long-term keeping are very significant factors in the preservation of photographs.

The basic structure of most photographic materials consists of a support upon which an emulsion layer is coated. The photographic emulsion consists primarily of a suspension of light-sensitive silver salts, known as silver halides, in gelatin. There are six principal materials of concern:

Support Material	Emulsion Layer
Glass	Gelatin
Paper	Silver
Film Base—nitrate	
—acetate	
—polyester	

A photograph made with these materials consists of an image or picture in the gelatin layer. The preservation of the image and its support is the primary subject of this book.

GELATIN

As indicated previously, most photographic emulsions consist of a silver halide or silver halides suspended in gelatin. After exposure, the silver halide affected by light is reduced by the developer to metallic silver; that part of the silver halide not affected by light is then removed by the fixer (hypo), leaving the metallic silver image suspended in the gelatin. Photographic gelatin is highly purified animal protein that is a very stable material as long as it is kept dry. The fact that gelatin will swell in water, and thus is permeable enough to permit the diffusion of processing chemicals through its structure also makes it susceptible to moisture throughout its life.

Gelatin can withstand a considerable amount of dry heat for a reasonable period, but heat in the presence of moisture gradually degrades it until it becomes sticky and soluble. It is also attacked by strong acids and acidic gases that are in the air or are formed by degradation of the support. Since gelatin is an organic substance, it readily promotes the growth of fungus under sustained conditions of high relative humidity. See "Storing Photographs under Tropical Conditions," on page 58.

It is generally considered that gelatin, if it is properly stored and protected from agents that degrade it, is stable enough to last as long as acetate film base.

GLASS

As an inert transparent material, glass is an ideal support for negative emulsions, but its physical

This three-part illustration shows the granular structure of the silver image, which becomes more apparent as the image is enlarged.

3

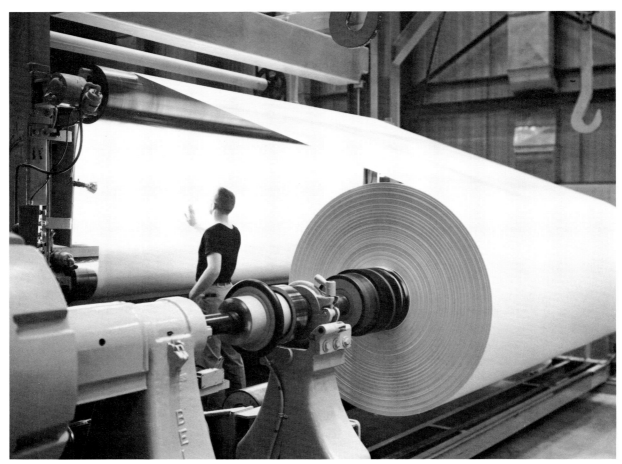

Inspecting photographic paper base by transmitted light. Eastman Kodak Company paper mill, Rochester, New York.

disadvantages of weight, bulk, and fragility make it an impractical material for general photography. Glass plates are still manufactured for certain technical applications in which dimensional stability is very important.

There are numerous glass plates in storage today, but generally they are a problem for custodians because of the space they occupy and their liability to breakage. Unfortunately, a great deal of valuable historical material has been destroyed for these reasons. Whenever it becomes possible, glass negatives should be cleaned and duplicated on film. See "Duplicating and Copying," on page 47.

PAPER

The history of papermaking is an interesting subject and one with which archivists are generally familiar. In this book, we are concerned only with the quality and permanence of paper used in printing photographs, and with those materials, such as mounting board, negative enclosures, interleaving paper, and so forth, that are associated with the keeping of photographs.

The purity of paper has always been of major concern to manufacturers of photographic materials, because there is a definite relationship between the purity of paper base and the keeping properties of an emulsion coated on it. At one time, practically all photographic paper base was manufactured from linen and cotton rags, but as the demand for paper of all kinds increased, the supply of suitable rags diminished. Dyes, pigments, and other materials were being used increasingly in the manufacture of cloth. Consequently, much of the rag stock that was available did not meet the purity standards required for photographic use. In an effort to solve the problem, Eastman Kodak Company instituted a program of research and development into the possibility of making pure paper from wood pulp. This step and the efforts of the pulp manufacturers themselves resulted eventually in a product that proved to be as good as or better than the best quality rag stock. This is not a new development; it took place over 40 years ago. Research still continues.

Today practically all photographic paper base is made from purified wood pulp as the raw material. Clearly then, the quality of the paper currently used

to make prints is not a subject for concern. Any deterioration seen in the paper base of a modern print is much more likely to have been caused by agents other than impurities in the paper base itself.

Water-Resistant Paper Base. In recent years, a number of photographic papers have been made on a base coated with synthetic resins. The practical advantages of this water-resistant paper lie in shorter fixing, washing, and drying times. Also, the paper has much less tendency to curl in storage or after being processed and dried. Glossy paper with the water-resistant base does not require ferrotyping (glazing); it dries naturally with a high gloss.

It seems probable that the advantages just mentioned will lead to the increased use of this type of paper in the future. If the need arises, the paper can be identified readily by feeling the base side of the print, which has a smooth surface similar to that of film. Also, most types of resin-coated paper cannot be written on with a medium-hard lead pencil.

Since resin-coated papers are a comparatively recent development, reliable long-term keeping data are not yet available. Kodak has based estimates of useful life upon accelerated aging tests, using elevated temperatures and controlled levels of humidity and radiant energy. From these studies, it appears that when black-and-white prints are stored in the dark, with only occasional viewing, and when the storage conditions are uniformly maintained near 21°C (70°F) and 50 percent relative humidity (RH), the useful life of resin-coated prints can be equal to the life of prints on conventional paper base.

In the manufacture of resin-coated base, Kodak utilizes the most advanced technology available to the company. Improvements are continually being introduced into the manufacturing operation. Until extensive testing and natural aging data indicate that prints on resin-coated paper base can be expected to last as long as prints on conventional paper base, black-and-white photographic papers without a resin coat will be produced by Eastman Kodak Company for those customers requiring long-term keeping under adverse storage or display conditions.

The effects of nitrate base decomposition. Gelatin becomes sticky and the base becomes brittle and easily broken.

NITRATE FILM BASE

As mentioned before, cellulose nitrate film base is relatively unstable, and in any considerable quantity it constitutes a fire hazard. It is chemically similar to guncotton, but contains somewhat less nitrogen in the molecule. Cellulose nitrate base is not explosive, but it is highly flammable.

Nitrate film base decomposes slowly under ordinary conditions, and the rate of decomposition is accelerated by increasing temperature and relative humidity. The products of decomposition—nitric oxide, nitrogen dioxide, and others—hasten the process unless allowed to escape from cans, boxes, and other packages. The usual effects of such decomposition are a yellowing of the film base and the gelatin of the emulsion, softening of the gelatin, and oxidation of the silver image. As decomposition proceeds, the base cockles, becomes extremely brittle, and then sticky. Finally, disintegration is complete.

The actual life of nitrate base films has varied widely; examples 50 or even 60 years old are still in a fair state of preservation, while others have deteriorated seriously in a much shorter time. Such wide differences in the rate of decomposition cannot be fully explained. However, rapid decomposition is most likely to have been caused by high temperature coupled with high relative humidity and by lack of ventilation. There seems to be little relationship between the rate of decomposition of nitrate base and the amount of residual processing chemicals—hypo and silver—present in the material.

Probability of Rapid Decomposition. Observations of old negatives on nitrate base show that aside from the adverse effects of excessive heat and humidity, the quantity of cellulose nitrate present in a container and the ability of the products of decomposition to escape have a definite bearing on

This picture was made about 40 years ago on a film with acetate base. Although the negative was subjected to many different atmospheric conditions, no deterioration of the film base is apparent.

the rate of decomposition. For example, a roll of motion-picture film, which represents a considerable bulk of cellulose nitrate, stored in a sealed can deteriorates fairly rapidly. This situation is one extreme. The other extreme is a number of small negatives, say about 5.7 x 8.3 cm (2¼ x 3¼ inches), kept in open-sided negative albums of good quality. Negatives on thin-base material stored in this way have remained in very good condition. A situation intermediate between the two just mentioned is where a number of large negatives, 20.3 x 25.4 cm (8 x 10 inches), for example, are stored in the original cardboard film box. Since sheet-film negatives have a thick base, there is a considerable amount of nitrate material present, and the products of decomposition are able to escape only slowly. Under these conditions, the negatives deteriorate more quickly than they do in the open-sided album or in some similar package. The archivist should, therefore, check the contents of enclosed packages of large negatives first of all.

Segregating Nitrate Base Negatives. Some of the products of deteriorating nitrate film are powerful oxidizing agents; consequently, these products attack other materials, such as any acetate-base negatives and prints that might be in contact with, or in the immediate vicinity of, decomposing nitrate film. This attack takes the form of yellowing and fading of the silver image and softening of the gelatin. Nitrate base negatives should, therefore, be segregated from other materials as soon as possible.

ACETATE FILM BASE

Because of the chemical instability and the dangerously flammable nature of cellulose nitrate film base, Eastman Kodak Company commenced an extensive program of research into other cellulose derivatives after World War I. By 1923 a substitute for nitrate base had been developed. This substitute was a slow-burning film known as cellulose acetate, or safety film. Amateur movie film was manufactured on this new support.

Cellulose acetate was not an entirely satisfactory replacement as a support for some other photographic purposes, however, and research on cellulose derivatives continued. This work resulted in the mixed esters of cellulose known as cellulose acetate propionate and cellulose acetate butyrate. The production of x-ray films was transferred to a cellulose mixed ester base, thus removing the fire hazard from hospitals and other places where large quantities of the film were used. Finally, cellulose triacetate

was developed, and up to a few years ago, used as the support for most Kodak films. By 1951 Kodak had discontinued the use of cellulose nitrate as a support for any film product, except the skin of a stripping film used in the graphic arts.

Since the changeover from one kind of film base to the other was gradual, the date that a particular negative was made will not indicate whether the base is nitrate or acetate, but a simple test can be made to distinguish one base from another. See "Identifying Nitrate Base," on page 33.

Stability of Acetate Film Base. To avoid the tedious repetition of chemical names, the term "acetate," as used here, refers to all of the cellulose acetate materials named in the preceding subsection.

The well-known instability of cellulose nitrate film base naturally raises a question about the stability of acetate bases. Accelerated aging tests in the laboratory, as well as some 45 years of observation, indicate that cellulose acetate has good stability and should provide satisfactory keeping properties for many centuries if stored under proper conditions.

During the early 1930's, the U.S. National Bureau of Standards conducted an investigation into the long-term stability of acetate film base. The tests were similar to those used to establish the permanence and durability of paper. The Bureau of Standards reported that, "On the basis of the test data, the cellulose acetate type of safety film appears to be very stable . . . While it is not possible to predict the life of acetate film from these results, the data show that the chemical stability of the film with respect to oven aging is greater than that of papers of maximum purity (designed) for permanent records."

POLYESTER FILM BASE

Polymers of the polyester type are currently being used to replace acetate base in a number of film products. ESTAR Base—the chemical name of which is polyethylene terephthalate—is such a base. Where permanence is concerned, accelerated aging tests and experience to date indicate that polyester film base is equal to or better than acetate materials. Moreover, it has great mechanical strength, high dimensional stability, and greater resistance to extremes of temperature than acetate bases.

Causes of Deterioration

The photographic silver image is very susceptible to chemical change. The finely divided form of the silver makes it particularly vulnerable to attack by residual processing chemicals, oxidizing gases in the atmosphere, and other agents often present in the vicinity of the storage area. These attacks are chemical reactions, of course, and like most such reactions they are accelerated by heat, particularly in the presence of moisture.

PROCESSING CONDITIONS

More deterioration of negatives and prints is due to the presence of residual processing chemicals in the material than to any other single cause. Moreover, deterioration due to outside agencies is always hastened by the presence of residual chemicals. These chemicals are sulfur-containing substances used for fixing—sodium thiosulfate or ammonium thiosulfate—and silver compounds formed as a result of the fixing reaction. Some of these compounds react with the silver of the image to form silver sulfide, which turns the image a brownish yellow. Under an extreme storage condition low-density image areas may be converted first to silver sulfide and then to white silver sulfate. This condition occurs rarely, but if it does occur the image is not chemically recoverable.

Residual silver compounds decompose and also form silver sulfide. This result is usually seen as an overall yellowish stain on the print or negative. An extremely small residue of silver compounds is sufficient to cause a slight overall stain. If a relatively large residue is present, the stain is much heavier and the residue contains sufficient hypo to affect the image as well.

Since the question of processing is such an important one in the preservation of photographs, the subject is discussed at length in the following section.

STORAGE CONDITIONS

Any adverse condition that prevails in a storage area becomes much more destructive in the presence of the residual chemicals described in the previous subsection. Prints, the processing conditions of which were known to be adequate, have lasted under normal indoor conditions for 50 years without any special storage methods. A temperate climate in which the temperature and relative humidity do not

This photograph shows the surface of a glass plate that was stored in a damp place for a long time. Fungus has attacked the gelatin and subsequent storage in dry conditions has caused the gelatin to crack and flake off.

rise above certain limits for a considerable length of time provides reasonably good conditions for the storage of prints that have been properly fixed and washed. This is true provided that any mounting boards, interleaving paper, album leaves, envelopes, and storage cabinets are free from injurious constituents.

Temperature of Storage Area. In general, a storage temperature not exceeding 21°C (70°F) is quite satisfactory for films and prints. Temperatures in excess of 21°C are not harmful for short periods. Lower temperatures are not harmful in any way, provided that they are not accompanied by high relative humidity. It should be noted that a fall in temperature is usually associated with an increase in relative humidity.

Relative Humidity. In the storage of negatives and prints, the effects of high relative humidity (in excess of 60 percent) must be avoided at all costs. Dampness is far more damaging than heat, and the two in combination are more destructive than either condition by itself. A relative humidity much above 60 percent for considerable periods hastens most of the deterioration seen in photographic materials, and in addition provides suitable conditions for the growth of mold or fungus. Also, high relative humidity can cause mounting boards and cardboard containers to disintegrate, as well as causing

enameled steel storage boxes or filing cabinets to rust. In tropical and subtropical climates where high temperatures and high humidity are present for long periods, special storage conditions are necessary. See "Storing Photographs under Tropical Conditions," on page 58.

Atmospheric Contamination. A considerable amount of deterioration is caused by oxidizing gases, such as hydrogen sulfide and sulfur dioxide, and the fumes present in the air in greater or lesser concentrations, depending on the locality. In large cities the problem is, of course, more severe than in areas of lower population and fewer industries. High concentrations of oxidizing gases in the storage area can result in gradual sulfiding of the silver image, as well as slow deterioration of gelatin on film or paper bases. Again, these effects are accelerated when residual processing chemicals are present in the material.

Another hazard due to oxidizing gases is caused by storing other material in the same container as nitrate negatives or Diazo Prints. Under certain conditions, the decomposition products of cellulose nitrate or Diazo Prints can effect serious damage to films on acetate bases, as well as to paper prints if they happen to be in the same closed container. See "Temporary Storage," on page 34.

MISCELLANEOUS CAUSES

Mounting boards, mountants, certain kinds of ink used for numbering or notation, adhesives, adhesive tapes, the paper used for making envelopes, interleaving paper, and certain plastic materials may all affect a silver image or its support in long-term storage.

The foregoing describes the main hazards of chemical changes that exist in the storage of photographs. There are other hazards of a more physical nature, of course; these include damage by flood, fire, water used to extinguish fire, malfunctioning sprinkler systems, collapse of building due to earthquake or other causes, and vandalism. Some of these risks are remote, but they exist, and where possible they should be considered in setting up storage facilities for very valuable records.

All of the above matters are discussed at greater length in later sections of this book.

Processing for Stability

As stated earlier in this book, the most important single reasons for the instability of black-and-white prints and negatives is improper processing—principally poor fixing and/or washing. With the best of intentions, photographers are not always aware of what constitutes proper processing procedures. If the manufacturer's processing and handling instructions for each material are carefully followed, very little more can be done to secure good keeping qualities in the negatives and prints except to store them under the recommended conditions.

This section is intended to provide an understanding of the principles that underlie proper processing of black-and-white negatives and prints. Special procedures applying only to prints are considered in the following section.

DEVELOPMENT

Little can be said about development in relation to stability, but generally the development conditions recommended by the manufacturers of the materials should be adhered to. Images developed for the finest grain tend to be more subject to attack by sulfiding agents than those of normal grain size. Greatly overexposed and underdeveloped images suffer from the same tendency.

STOP BATH

The purposes of a stop bath are to stop the action of the developer at the desired point, to prevent stain, and to extend the life of the fixing bath by reducing the carry-over of developer solution. The strength of the stop bath should not exceed that recommended, for two reasons: (1) excess acetic acid can affect the physical condition of some types of photographic paper support, causing it to become brittle during drying and storage; (2) excess acetic acid can react with the sodium carbonate in some developers to produce carbon dioxide gas, which can cause blisters in film emulsions or gas bubbles trapped within the paper structure of prints. In the latter case, hypo and silver compounds trapped in the pockets are difficult to wash out, and as a result, small brown spots appear on the print after a period of keeping (or immediately if the print is sulfide-toned).

The acidity of an acetic acid stop bath is about pH 3.5 when fresh and pH 5.5 at exhaustion. Proprietary stop baths, such as KODAK Indicator Stop Bath, are available that contain a dye indicator giving a

yellow-colored solution when the bath is fresh and a purple-colored solution when it is exhausted. A stop bath that does not contain an indicator dye can be tested as described in the following subsection.

Replenishment of an exhausted film stop bath with 28 percent acetic acid is possible. However, replenishment is to be avoided with print stop baths, because reaction products accumulating during use may cause a variety of mottle patterns if the print is subsequently toned.

Testing a Print Stop Bath. Fill a clean 30-mL (1-fluidounce) vial about three-quarters full with the stop bath. To this add 2 drops of KODAK Stop Bath Test Solution SBT-1. An acid stop bath that is still useful will remain yellow. When the acid has been neutralized, the bath will turn purple, and should be replaced. Under a KODAK Safelight Filter OC (light amber) the yellow color is not noticeable, but the purple color appears dark.

KODAK STOP BATH TEST SOLUTION SBT-1

Water (distilled or demineralized)
 at 26.5°C (80°F)750 mL
KODAK Sodium Hydroxide
 (Granular) 6.0 g
*With stirring add EASTMAN
 Bromocresol Purple (CAT. No. 745)
 . 4.0 g
Mix for 15 to 20 minutes, then add
‡Phosphoric Acid (86%) 3.0 mL
Water to make 1.0 L

Caution: Sodium hydroxide is caustic and is capable of causing severe burns in all tissues. Special care should be taken to prevent contact with skin or eyes. A face shield or goggles should be used when handling this chemical.

Phosphoric acid is a strong, nonvolatile inorganic acid. It is corrosive to tissue and can cause severe skin or eye burns. Impervious gloves and goggles should be worn when handling the concentrated solution.

*EASTMAN Organic Chemicals can be obtained from many laboratory supply dealers.

‡Add the concentrated (86%) acid to the aqueous solution. Never add the solution to the concentrated acid.

In case of contact with either of these chemicals, immediately flush the involved areas with plenty of water; for eyes, get prompt medical attention.

FIXING

To make a negative or print as stable as possible, two conditions must be met: (1) All of the undeveloped silver halides in the emulsion must be dissolved by the fixing solution so that the soluble silver compounds thus formed can be removed from the material by washing. (2) Both the fixing chemicals and the soluble silver compounds must be removed from the emulsion and its support by thorough washing.

Fixing Time. A single sheet of film or paper fixes in a relatively short time in a fresh fixing bath, because fresh solution is in contact with the whole surface of the material throughout the immersion time. When a batch of prints or negatives are fixed together in a tray, a different condition exists. The sheets of material adhere to one another, and so prevent access of fresh solution to the surfaces. For this reason, photographic materials must be agitated and separated constantly throughout the fixing time. The effect of lack of agitation is often seen as a stained patch in the center of the negative or print, indicating that solution reached the edges of the material but failed to reach the center of the sheets. This bunching of negatives or prints during fixing is one of the most common causes of deterioration.

Each fixing time recommended by Kodak includes a safety factor that helps to compensate for the difficulties in fixing material in batches and for the slowdown of the fixing reaction by a buildup of silver compounds in the hypo solution. The fixing times recommended should not be exceeded, particularly in the case of paper prints. See "Exhaustion Life of a Paper-Fixing Bath," on page 12.

Practical Limits for Concentration of Silver in Fixing Baths. When the concentration of silver in a fixing bath reaches a certain level, insoluble silver compounds are formed that fail to leave the material in washing. A higher concentration of silver can be tolerated in a fixing bath for negatives than in one for papers. This is because chemical solutions are not absorbed by the film base. Removal of residual chemicals is therefore relatively simple. The maximum amount of silver that should be allowed to accumulate in a bath used for negatives is about 6.0 grams per litre of sodium thiosulfate fixer. With an

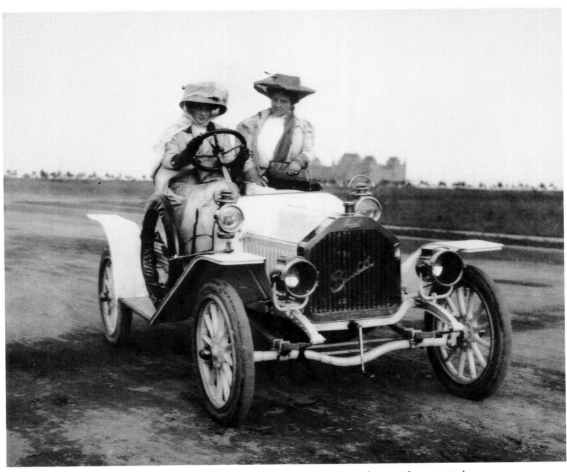

The reasons for taking photographs were the same then as they are today.

ammonium hypo fixer, the maximum is nearly 13.0 grams of silver per litre, because silver-ammonium hypo compounds wash out more rapidly than silver-sodium hypo compounds. As a general rule, the limit with either type of fixing bath has been reached when a film takes twice the time to clear that the same film would take in a fresh bath.

In fixing papers, the situation is more complex; chemical solutions are absorbed by the paper base and the baryta coating on the paper, as well as by the emulsion. As a result, residual chemicals are much more difficult to remove by washing. Experiments have shown that not more than 2.0 grams per litre of silver can be tolerated in a fixing bath used for papers. Obviously, when a single fixing bath is used for prints it must be tested frequently; otherwise, the permissible level of silver can easily be exceeded without the knowledge of the operator. A more certain method of fixing prints is to use the two-bath system described on the next page.

Fixing Negatives. A few negatives can be fixed in a tray if they are separated and handled carefully. In batch processing, the best method is to use suitable film hangers suspended in a tank. In this way the films are always properly separated. Fixing is carried out with the minimum of handling, and consequently, less damage.

About twenty-six 20.3 by 25.4-cm (8 by 10-inch) films can be fixed per litre of hypo solution. However, if the number of films processed is uncertain, the condition of the fixing bath can be checked by observing the time the film takes to clear. If it takes twice the time to clear that the same film would take in a fresh bath, the solution should be discarded. Remember that some types of film take much longer to clear than others; therefore, the same film must be used to check the clearing time in both the fresh bath and the used bath. Whether it is exhausted or not, a tank of hypo should be discarded after one month of use.

Fixing Prints. Prints are usually fixed in a tray and often in fairly large batches. Consequently, precautions must be taken to be sure of complete fixing if the prints are to be stable.

Always use trays or tanks that are large enough to permit easy handling of the prints. For example, not more than twelve 20.3 by 25.4-cm (8 by 10-inch) prints can be fixed properly in an ordinary 41 by 51-cm (16 by 20-inch) processing tray.

The following question is often asked: "Should prints be placed in the fixer face upward or face downward?" The answer is that most prints on conventional photographic paper base float on the surface of the solution and cannot be left unattended for any length of time no matter which side is upward. Bubbles form under a print that floats face downward; consequently, some areas are only partially fixed. The effect may not be apparent in a straight black-and-white print, but it will be seen as circular purplish stains in a print toned by one of the sulfide processes. A print that floats face upward exhibits the same effect, but the purplish stains are irregular in shape.

Exhaustion Life of a Paper-Fixing Bath. As stated earlier, the useful life of a print-fixing bath is shorter than that of a bath used for fixing negatives. There are two reasons for this: (1) Owing to the physical nature of paper, silver compounds are absorbed. (2) There is more carry-over of stop bath or rinse water to the fixer than in film processing; thus the hypo solution is diluted and its working strength reduced. This situation cannot be corrected by increasing the fixing time, because there is a significant relationship between fixing time and washing time in print processing. The recommended fixing time for prints on conventional-base papers is 5 to 10 minutes. Times in excess of 10 minutes permit the hypo solution, and the silver compounds it bears, to penetrate the paper fibers, as well as the spaces between the fibers. Paper in this condition is difficult to free from residual chemicals by washing. After a period of keeping, the effect can be seen as an overall yellow stain that extends right through the paper base. It may become apparent immediately if the print is toned by one of the sulfide processes.

Note that it is particularly important not to fix prints on resin-coated papers longer than the recommended times, which are shorter than for prints on regular-base papers. Prolonged fixing of resin-coated papers would allow the fixing bath to penetrate the uncoated edges of prints to an extent that silver compounds could be washed out again only with difficulty. Thus a major advantage of the water-resistant base, the short fixing and washing times, would be lost, and there would be danger of subsequent stain formation on the edges of prints, even with extended washing.

Fixing Prints in a Single Bath. As successive sheets of paper are fixed in a bath of hypo, the quantity of silver in the solution builds up. When prints are fixed, a critical concentration of silver is reached after comparatively few sheets of paper have been fixed. The recommended number of 20.3 x 25.4-cm prints per litre of solution (or the equivalent area in other sizes) is about 26 for commercial processing. However, if prints with the minimum tendency to stain are required, the bath should be discarded after only eight 20.3 x 25.4-cm sheets of paper per litre have been processed. These figures give only an approximate estimate of the condition of a fixing bath, because the amount of silver compounds added to the solution by a print depends on how much of the silver halide in the emulsion was developed to metallic silver. Obviously, less silver halide is left in a very dark print than in a very light one. See "Testing Print-Fixing Baths," page 13.

Two-Bath Fixing. If space permits, it is always preferable to use the two-bath fixing method in print processing. This method is much more efficient and effects a considerable economy in chemicals. The prints are fixed for 3 to 5 minutes in two successive baths. The major part of the silver halide is dissolved in the first bath, and the remainder is dissolved or rendered soluble by the second bath. To use two baths, follow this procedure:

1. Mix two fresh fixing baths and place them side by side.

2. Fix the prints for 3 to 5 minutes in each bath.

3. Discard the first bath when fifty-two 20.3 x 25.4-cm prints per litre of solution have been fixed.

4. Substitute the second bath for the one just discarded; the second bath has now become the first one.

5. Mix a fresh bath and place it beside the first one.

6. Repeat the above cycle four times.

7. After five cycles, mix fresh solution for both baths.

8. If five cycles are not used in one week, mix

fresh solution for each bath at the beginning of the second week.

Two-bath fixing is also good practice with resin-coated papers. Fix the prints for 1 minute in each bath, draining them for 5 seconds between baths. Discard the first bath when ninety-two 20.3 x 25-cm prints per litre of solution have been fixed, and discard both baths after *four* cycles, or after one week, if sooner.

Testing Print-Fixing Baths. If a single fixing bath is used for prints, test the solution frequently with KODAK Fixer Test Solution FT-1 to avoid an undesirable buildup of silver compounds. In using the two-bath method, test the second bath only occasionally. As a rule, the test is negative if the method is operated carefully, but omissions and accidents sometimes occur in a busy darkroom. Therefore, the test is worthwhile if permanence is important.

KODAK FIXER TEST SOLUTION FT-1

Water at 26.5°C (80°F) 750 mL
KODAK Potassium Iodide190 g
Water to make 1.0 L
The mixed solution can be stored in a stoppered brown bottle for one year.

Single-Bath Fixer: To 5 drops of KODAK Fixer Test Solution FT-1, add 5 drops of the fixing bath to be tested and 5 drops of water. Discard the fixer if a yellow-white precipitate forms instantly. Any slight milkiness should be disregarded.

Two-Bath Fixer:
 First Bath: Test as described above for a single-bath fixer.
 Second Bath: To 5 drops of KODAK Fixer Test Solution FT-1, add 5 drops of the fixing bath to be tested and *15* drops of water.

If both tests result in a yellow-white precipitate, replace both baths with fresh fixing baths. If only the first bath forms a precipitate, replace the first bath with the second, and replace the second bath with a fresh bath.

WASHING

In photographic processing, the purpose of washing is to remove the fixing chemicals and silver compounds that remain in the material. Washing negatives is a fairly simple operation because chemicals are not absorbed by the film base. Under suitable conditions, negatives are freed from residual chemicals after 20 to 30 minutes of washing.

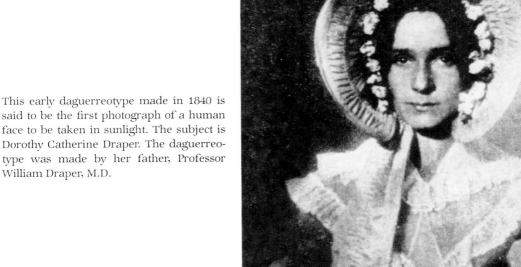

This early daguerreotype made in 1840 is said to be the first photograph of a human face to be taken in sunlight. The subject is Dorothy Catherine Draper. The daguerreotype was made by her father, Professor William Draper, M.D.

Washing prints on regular paper base is a different situation; chemicals are absorbed by the base, and to remove them completely by washing alone is difficult. Under favorable conditions, prints are washed well enough for most purposes after 1 hour. If prints are intended as permanent records, they should be treated with KODAK Hypo Eliminator HE-1 to remove the last traces of hypo that remain after normal washing.

Washing Apparatus. The water in any tray or tank used for washing photographic materials should flow at a rate sufficient to fill the vessel in 5 minutes. This rate should be achieved without excessive turbulence, which can damage the films or prints, and without splashing adjacent walls or floors.

Dirty washers are a source of print stains that may be difficult to account for. Therefore, washing apparatus should be kept clean by frequent wiping and rinsing. Sodium hypochlorite solution, commonly available as a bleach sold for laundry use, is helpful in removing the slime that tends to accumulate in washers that are not cleaned frequently. Flush the washer thoroughly with clean water after using any chemical.

A test to determine the rate of change of water in a washer can be made quite simply. Add a small quantity of concentrated liquid food coloring or potassium permanganate solution to the water in the tray or tank and observe the time the color takes to disappear. Before making this test, however, be sure that the washer is free from any slimy deposit that might retain the coloring material. Also, if potassium permanganate is used, be sure that the wash water is not contaminated by hypo, because weak permanganate solution is made colorless by hypo.

Water Supply. A plentiful supply of pure water is desirable in processing photographic materials for permanence. Municipal water supplies are generally satisfactory for washing negatives and prints. Water may be either hard or soft, according to the amount of calcium or magnesium salts dissolved in it. The degree of hardness usually has little effect on stability, although very soft water permits gelatin to swell excessively, especially water treated in softeners to remove salts; this may be troublesome in some processes.

To future generations of people, today's cameras, clothing, and automobiles will appear just as old fasioned as they do in this photograph.

Water from a well or other untreated source may contain sulfides or dissolved vegetable matter. The presence of sulfides can be detected by an odor of hydrogen sulfide (like rotten eggs) when the water is heated. A greenish color in the water indicates dissolved vegetable matter. These impurities can be removed by suitable filtration or treatment.

Generally, it is safe to assume that water is satisfactory for photographic washing if it is clear and colorless, and does not have a sulfide odor on being heated.

Wash-Water Temperature. The temperature of the wash water has a definite effect on the rate of removal of hypo and silver complexes from both films and prints. Residual chemicals are washed out with increasing difficulty at temperatures below 16°C (60°F). When practical considerations as well as the physical characteristics of film and paper are taken into account the most suitable range of temperature for sink-line washing is 18 to 24°C (65 to 75°F). See "KODAK Hypo Clearing Agent," below.

Washing Negatives. A small batch of films or plates can be washed in a tray, but avoid excessive turbulence, because these materials tend to scratch one another if allowed to move about too rapidly. The KODAK Automatic Tray Siphon is an attachment that provides adequate water change in a shallow tray.

Large batches of negatives should be suspended in hangers and washed in a tank. With suitable hangers, both films and plates can be washed in this way. For good water circulation, the inlet should be positioned at one corner of the bottom of the tank. Allow the water to overflow at the top edges of the tank. Do not use a single outlet at the top, which tends to produce a pattern of currents that may leave certain areas in the tank comparatively stagnant, and so reduce the rate of complete water change.

To conserve water and reduce the cost of washing, do not wash negatives much longer than the recommended 20 to 30 minutes. It is also wasteful to use an unnecessarily high rate of water flow or to wash negatives in a tank much bigger than that needed to accommodate the size or quantity of material being washed.

The actual time required in a washing system to reach the desired residual hypo level can be determined by making frequent tests. See "Testing for Hypo," page 17.

If small air bubbles tend to form on the film, insert an aspirator (filter pump) in the wash-water line and adjust it to permit a steady flow of air into the water. The resulting larger air bubbles will not cling to the film.

Washing Prints. For most purposes, adequate washing is achieved in 1 hour if the water flows at a rate sufficient to fill the washer in 5 minutes. However, the time of washing and the rate of water flow are both meaningless if the prints are not separated constantly so that water can reach every part of each print throughout the washing time. A well-designed washer can do this fairly well with small prints up to about 12.7 x 17.8-cm (5 x 7-inches); larger prints need frequent handling to keep them separated. A number of well-designed washers are available from photographic dealers. No washer, however, can perform satisfactorily if too many prints are washed in it at one time. Use two or more tanks and wash the minimum number of prints in each.

To conserve water, three washers can be arranged in series to permit countercurrent movement of the prints. Each washer is at a higher level than its predecessor, with fresh water coming into the final and highest tank. Prints are moved at regular intervals from the lowest tank—where the bulk of hypo is removed—to the intermediate tank and then to the upper tank, where washing is completed by the incoming fresh water. Incidentally, do not guess at the washing time; use a timer.

Prints on resin-coated papers wash more rapidly than prints on conventional-base papers. The actual time required is best determined by making hypo tests on prints from the first batch or two processed.

KODAK HYPO CLEARING AGENT

Experiments have shown that seawater removes hypo from photographic materials more quickly than fresh water. Investigations into this effect revealed that certain inorganic salts behave like the salts in seawater. Unlike seawater, however, they are harmless to the silver image. KODAK Hypo Clearing Agent is a preparation of such substances. Its use reduces the washing time for both negatives and prints. At the same time, prints attain a degree of freedom from residual chemicals almost impossible to attain by washing them with water alone. A further advantage in using KODAK Hypo Clearing Agent is that adequate washing can be achieved with much colder water.

REFERENCE CHART—KODAK HYPO CLEARING AGENT

Photographic Material	Rinse After Fixing	Hypo Clearing Agent	Wash in Running Water	Capacity (20.3 x 25.4-cm prints per litre)	Capacity (8 x 10-inch prints per gallon)
Films	none	1-2 minutes	5 minutes	12-15 or equivalent	50-60 or equivalent
Films	30 seconds	1-2 minutes	5 minutes	35-50 or equivalent	150-200 or equivalent
Single-Weight Prints	none	2 minutes	10 minutes	20 or equivalent	80 or equivalent
Single-Weight Prints	1 minute	2 minutes	10 minutes	50 or equivalent	200 or equivalent
Double-Weight Prints	none	3 minutes	20 minutes	20 or equivalent	80 or equivalent
Double-Weight Prints	1 minute	3 minutes	20 minutes	50 or equivalent	200 or equivalent

Films and Plates. Rinse films or plates in fresh water for 30 seconds to remove excess hypo, and then immerse them in KODAK Hypo Clearing Agent solution for 2 minutes with agitation. Wash them for 5 minutes in a tank in which the water changes completely in 5 minutes. To avoid streaks, drying marks, and the formation of water droplets on film surfaces, bathe films in KODAK PHOTO-FLO Solution for 30 seconds and then hang them up to dry.

Papers. Rinse prints in fresh water for 1 minute to remove excess hypo. Treat single-weight papers for 2 minutes, with agitation, in KODAK Hypo Clearing Agent solution and then wash them for at least 10 minutes. Observe the normal recommendations concerning water flow. The prints must, of course, be agitated and separated throughout the washing time.

Rinse double-weight papers for 1 minute in clean water; then immerse them in KODAK Hypo Clearing Agent solution for 3 minutes. Wash the prints for at least 20 minutes with normal water flow and constant agitation.

Prints can be transferred to the Hypo Clearing Agent solution directly from the fixer without an intermediate rinse. This practice, however, considerably reduces the capacity of the Hypo Clearing Agent solution. For the capacity of the solution with and without intermediate rinsing, see the reference chart.

Because of the rapid washing characteristics of resin-coated papers, the use of KODAK Hypo Clearing Agent with these materials offers little advantage and is not recommended.

TESTING FOR SILVER

An overworked fixing bath contains complex silver thiosulfate compounds that are retained by the films or prints and cannot be removed completely by washing. These salts lead to stains that may not become evident for a period of time. Since the quantity of silver compounds necessary to cause an overall yellow stain on a print or negative is extremely small, there is no simple quantitative method available for its determination. However, the stain that might be visible after a period of keeping can be simulated by the following drop test: Place a drop of KODAK Residual Silver Test Solution ST-1 (formula given below) on an unexposed part of the processed negative or print and blot off the surplus solution with a piece of clean white blotting paper or absorbent tissue.

Any yellowing of the test spot, other than a barely visible cream tint, indicates the presence of silver. If the test is positive, residual silver can be removed by refixing the print or negative in fresh hypo and rewashing for the recommended time. Prints toned in a sulfide toner or selenium toner will not yield to this treatment, however, because the residual silver has been toned together with the image. The yellow stain so formed is permanent.

KODAK RESIDUAL SILVER TEST SOLUTION ST-1

Water . 100 mL
Sodium Sulfide (Anhydrous) 2 g

Store in a small stoppered bottle for not more than 3 months. Note that the silver test solution is made with sodium *sulfide*, not sulfite. Handle solutions of sodium sulfide carefully and avoid breathing the vapor.

For Use: Dilute 1 part of stock solution with 9 parts of water. The diluted solution has limited storage life and should be replaced weekly.

Testing with KODAK Rapid Selenium Toner. If you wish to use a more stable reagent than KODAK Residual Silver Test Solution ST-1, you can use a dilute solution of KODAK Rapid Selenium Toner to test whether prints are thoroughly fixed. This solution keeps well, at working dilution, for a long period.

To use, dilute 1 part of KODAK Rapid Selenium Toner with 9 parts of water. These proportions are not critical. Using this solution, follow the directions given above for the use of KODAK Residual Silver Test Solution ST-1.

NOTE: This test does not work with stabilized prints or where a large excess of hypo is present, as in unwashed prints.

TESTING FOR HYPO

The residual hypo content of films and prints can be accurately determined only by actually testing the processed photographic material. This is particularly true in the case of prints, because the paper support retains hypo in its fiber structure. Either the KODAK Hypo Test Kit, sold by photo dealers, or the following solution can be used.

KODAK HYPO TEST SOLUTION HT-2

Water .750 mL
KODAK 28% Acetic Acid125.0 mL
KODAK Silver Nitrate, Crystals 7.5 g
Water to make 1.0 L

*To make approximately 28% acetic acid from glacial acetic acid, add 3 parts of glacial acetic acid to 8 parts of water.

Store the solution in a screw-cap or glass-stoppered brown bottle, away from strong light. At 18 to 24°C (65 to 75°F), it will keep for about 6 months. Do not allow the solution to come in contact with hands, clothing, negatives, prints, or undeveloped photographic material; it will stain them black.

"Logging," a 1914 picture of logging operations near White Sulfur Springs, Virginia. Photo. by Rev. W. Harvey Young.

Testing Prints. To determine whether prints are thoroughly washed, wipe the excess water from the face (emulsion side) of an unexposed piece of the same paper being used in the batch of prints being processed, or from the extra margin area of one of the prints. Place 1 drop of the test solution on the face of the processed paper sample. Allow the solution to stand on the sample for 2 minutes, rinse to remove the excess reagent, and compare the stain with the tints shown in the KODAK Hypo Estimator or the KODAK DARKROOM DATAGUIDE, both available from photo dealers. Note that this test gives a qualitative rather than quantitative estimate of the degree of washing.

Note also that test results are significantly different for prints on regular and water-resistant paper base. Prints on resin-coated papers should show very little or no discoloration with the HT-2 test, with an acceptable spot density of Patch 1 or below. Prints on resin-coated papers testing similar to Patch 3 contain objectionably high hypo levels.

For prints on non-resin-coated papers with good long-term keeping properties, use washing aids such as KODAK Hypo Clearing Agent and KODAK Hypo Eliminator HE-1. If the above spot test is used after a washing aid other than KODAK Hypo Clearing Agent, it may give misleading results. The face may show less stain than a print washed only in water, and yet the hypo content of the two prints may be equal. In cases where, for this reason, results obtained with KODAK Hypo Test Solution HT-2 may be unreliable, it may be preferable to measure the density of the material after treatment with the silver nitrate test solution. See ''Quantitative Test for Hypo in Prints,'' below.

Testing Films. After washing, cut off a small strip from the clear margin of the film and immerse a portion of it in a small volume of the test solution for about 3 minutes. Well-washed films, including those for record purposes, should show very little or no discoloration.

The spot technique should not be used on wet films because of the danger of spreading the reagent. It is very useful in testing dry films.

Quantitative Test for Hypo in Prints. The amount of hypo in photographic paper can be determined quantitatively by the first procedure described in the American National Standard Methylene Blue Method for Measuring Thiosulfate and Silver Densitometric Method for Measuring Residual Chemicals in Films, Plates, and Papers, ANSI

PH4.8-1971. The second procedure, which is simpler to perform, measures not only thiosulfate but also polythionates and other residual chemicals. In this method, acidified silver nitrate is applied to an unexposed part of the processed print. Excess silver nitrate is removed with sodium chloride solution to convert the silver salt to silver chloride, which is then dissolved out in hypo. This step is necessary because the excess silver nitrate would darken in light and yield a false analysis.

The reflection densities of the paper before and after treatment with the silver nitrate solution are read on a densitometer equipped to measure Status A blue density. The difference between these density readings indicates the amount of hypo in the material.

Quantitative Test for Hypo in Films. The residual hypo in processed film can be determined quantitatively by the techniques described in the American National Standard Methylene Blue Method for Measuring Thiosulfate and Silver Densitometric Method for Measuring Residual Chemicals in Films, Plates, and Papers, ANSI PH4.8-1971. Hypo limits are given in the American National Standard Specifications for Photographic Films for Archival Records, Silver-Gelatin Type, on Cellulose Ester Base, ANSI PH1.28-1976, and on Polyester Base, ANSI PH1.41-1976.

NOTE: Not all of the practical recommendations given in this text fall within the scope of *current* ANSI specifications. The ANSI standards do not prevent anyone from using products, processes, etc, not conforming to the standards.

Print Stability Procedures

As stated in the previous section, normal processing, following recommended procedures, produces an excellent level of stability in prints. Only those interested in assuring extended stability need consider additional treatment. Hypo elimination will remove all residual thiosulfate ion, and silver thiosulfate complexes, but black-and-white prints so treated will remain subject to image attack from external causes.

The image can be protected from external attack by modification or conversion to a less reactive form. Toning methods that convert all or substantially all of the image to silver sulfide or silver selenide, or that

Photography is a unique recording medium that can preserve a priceless instant in time to be enjoyed by future generations.

modify the image by the deposition of gold, produce very stable images. The following toners produce such images: KODAK Hypo Alum Sepia Toner T-1a, KODAK Sulfide Sepia Toner T-7a, KODAK Sepia Toner, KODAK Polysulfide Toner T-8, KODAK Brown Toner, KODAK POLY-TONER, and KODAK Blue Toner. Prints fully toned in KODAK Rapid Selenium Toner also have very stable images.

Prints partially toned in KODAK Rapid Selenium Toner and prints toned to a medium brown tone in KODAK Gold Toner T-21 have good stability to oxidizing gases. However, they must be properly washed to remove the hypo contained in the toner.

Prints toned in KODAK Hypo Alum Sepia Toner T-1a are known to be more resistant to fungus attack in tropical areas than prints treated in other ways.

Selection of a paper-toner combination depends on the acceptability of the image color produced. Generally, those combinations listed as primary recommendations in the Toning Classification Chart given in Kodak publications deserve first consideration.

If for any reason the brown color of a sepia- or selenium-toned print is unacceptable, the cold, blue, or blue-black tones produced by KODAK Blue Toner

may be desirable. If a minimum change in image tone is desired, use of KODAK Gold Protective Solution GP-1 may be preferred.

Formulas and instructions for use of KODAK Hypo Alum Sepia Toner T-1a and KODAK Sulfide Sepia Toner T-7a are given in this section; formulas for the other numbered toners are given in KODAK Data Book No. J-1, *Processing Chemicals and Formulas for Black-and-White Photography.* KODAK Sepia Toner (similar to T-7A), KODAK Brown Toner (similar to T-8), KODAK Rapid Selenium Toner, KODAK POLY-TONER, and KODAK Blue Toner are supplied in prepared form through photo dealers.

HYPO ELIMINATION

It is difficult to remove the last traces of processing chemicals from photographic paper by ordinary means. For maximum stability of prints, therefore, use of a hypo eliminator is recommended after washing.

In the past, many different formulas have been used as hypo eliminators, but most of them failed to oxidize hypo to harmless sodium sulfate. As a result, intermediate compounds, such as tetrathionate, were formed; these compounds were just as harm-

19

ful to the silver image as hypo itself. In recent years an alkaline hypo eliminator has been used with much more success. This formula, called KODAK Hypo Eliminator HE-1, reduces hypo all the way to sodium sulfate, which is harmless to the silver image and soluble in the final washing.

KODAK HYPO ELIMINATOR HE-1

Water .500 mL
Hydrogen Peroxide (3% solution) . .125.0 mL
*Ammonia solution100.0 mL
Water to make 1.0 L

*Prepared by adding 1 part of concentrated ammonia (28%) to 9 parts of water.

Caution: Prepare the solution immediately before use and keep in an open container during use. Do not store the mixed solution in a stoppered or screw-cap bottle, or the gas evolved may break the bottle.

Also, *do not use HE-1 on film negatives.* The gas formed may cause blistering of the film emulsion, which is likely to be softer than that of a print.

Procedure: Treat the prints with KODAK Hypo Clearing Agent or wash them for about 30 minutes at 18 to 21°C (65 to 70°F) in running water that flows rapidly enough to replace the water in the vessel (tray or tank) completely once every 5 minutes. Then immerse each print about 6 minutes at 20°C

These two prints, one black-and-white and the other sepia toned, were mounted together in the same folder. Note the silver stain on three edges of the black-and-white print on the right. This is an atmospheric effect that is less likely to occur in toned prints than in black-and-white.

(68°F) in the Hypo Eliminator HE-1 solution, and finally wash about 10 minutes before drying. At lower temperatures, increase the washing times.

Useful Capacity: About thirteen 20.3 x 25.4-cm prints per litre (fifty 8 x 10-inch prints per gallon).

TONING

Prints that have been toned by one of the processes that convert metallic silver to silver sulfide or silver selenide are generally more stable than untoned prints. This is because silver sulfide and silver selenide are less liable to attack by oxidizing gases in the atmosphere, and because successful toning depends on proper washing and fixing. Any short-coming in processing is readily exposed by the toning process. Consequently, a toned print of good quality is obviously free from residual chemicals and is as stable as a print can be.

Several processes exist for toning or altering the color of a silver image, but not all such processes are suitable for use if the prints are intended for long-term keeping. For sepia or brown toning, the most suitable methods are the hypo-alum process using KODAK Hypo Alum Sepia Toner T-1a and the bleach-and-redevelop sepia process employing KODAK Sulfide Sepia Toner T-7a or KODAK Sepia Toner. If for any reason, the brown color of a sepia-toned print is unacceptable, an alternative is to treat the print with KODAK Gold Protective Solution GP-1. This is not a toning process in the ordinary sense of the term, because the color of the image is not altered greatly. The silver grains of the image are coated with gold, which protects them against attack by atmospheric agents.

Of the two sepia toning processes mentioned above, the bleach-and-redevelop sepia process is preferable from the standpoint of long-term keeping of prints, because the solutions are used at normal temperature, and they do not contain hypo. More-over, any deficiencies in processing are revealed in the toned print, because in bleaching the image, a silver halide is formed that is very sensitive to the presence of residual hypo. When hypo is present, weak yellow images are formed, or patchy yellow stains, or overall yellow stain, or all three conditions may occur at the same time. Also, if residual silver is present, it tones in the same manner as the image and is revealed as an overall stain in the highlights and borders of the print.

Although prints toned by the hypo-alum process have proven to be very stable, it requires the use of a

hot solution and the tone obtained with some papers tends to be purplish. Note that both of these toners are generally unsuitable for toning warm-tone por-trait papers, because the prints lose contrast and tone with a yellowish cast.

Following are the formulas and toning procedures for KODAK Hypo Alum Sepia Toner T-1a and KODAK Sulfide Sepia Toner T-7A. The emulsion of prints toned by the latter process tends to be soft and easily marked; hardening is therefore required, and this can be effected by using KODAK Hardener F-5a, the formula for which is also given.

NOTE: Do not tone old prints or those printed on unknown papers or processed under unknown conditions. Sometimes tests for hypo and silver in the prints may indicate the possibility of refixing and rewashing, then toning.

KODAK HYPO ALUM SEPIA TONER T-1a

Cold water 2.8 L
KODAK Sodium Thiosulfate
 (Pentahydrated)480.0 g

Dissolve thoroughly, and add the following solution:
Hot water, about 70°C (160°F)640 mL
KODAK Potassium Alum, Fine
 Granular (Dodecahydrated)120.0 g
Then add the following solution (including precipitate) slowly to the hypo-alum solution while stirring the latter rapidly:
Cold water 64 mL
KODAK Silver Nitrate, Crystals 4.0 g
Sodium Chloride 4.0 g

After combining the above solutions, add
Water to make 4.0 L

NOTE: Dissolve the silver nitrate completely before adding the sodium chloride, and imme-diately afterward add the solution containing the milky white precipitate to the hypo-alum solution as directed above. The formation of a black precipitate in no way impairs the toning action of the bath if the proper manipulation technique is used.

Procedure: Pour the toner solution into a tray supported in a water bath and heat it to 49°C (120°F). At this temperature, prints will tone in 12 to 15 minutes, depending on the type of paper. Never use the solution at a temperature above 49°C

Courtesy of International Museum of Photography.

"The Terminal" by Stieglitz, 1893. From the original lantern slide.

(120°F) or blisters and stains in the prints may result. Do not continue toning longer than 20 minutes at this temperature.

This toner causes losses of density and contrast that can be corrected by increases in exposure (up to 15%) and developing time (up to 50%). The actual increases depend on the kind of paper.

Thoroughly fix the prints to be toned and wash them for 5 to 15 minutes before placing them in the toning bath. Soak dry prints thoroughly in water. Immerse the prints completely and separate them occasionally, especially during the first few minutes.

After prints have been toned, wipe them with a soft sponge and warm water to remove any sediment, and wash them for 1 hour in running water or treat them with KODAK Hypo Clearing Agent as recommended.

KODAK SULFIDE SEPIA TONER T-7a

Stock Bleaching Solution A

Water . 2.0 L
KODAK Potassium Ferricyanide
　(Anhydrous) 75.0 g
Potassium Oxalate195.0 g
KODAK 28% Acetic Acid 40.0 mL

To make approximately 28% acetic acid from glacial acetic acid, add 3 parts of glacial acetic acid to 8 parts of water.

Stock Toning Solution B

Sodium Sulfide (Anhydrous) 45.0 g
Water .500 mL

Prepare Bleaching bath as follows:
Stock Solution A500 mL
Water .500 mL
Prepare Toner as follows:
Stock Solution B 125 mL
Water to make 1.0 L

Procedure: First, thoroughly wash the print to be toned. Place it in the bleaching bath (prepared from solution A) and allow it to remain until only a faint yellowish brown image remains.

NOTE: Do *not* use chipped enamel trays with any iron exposed; otherwise, blue spots may be formed on the prints. Plastic trays are the most suitable.

Rinse the print *thoroughly* in clean, cold running water (at least 2 minutes).

Treat the print in the toning bath (prepared from Solution B) until the original detail returns. This will require about 30 seconds. Give the print an immediate and thorough water rinse; then treat it for 2 to 5 minutes in a hardening bath composed of 1 part of KODAK Liquid Hardener and 13 parts of water, or 2 parts of KODAK Hardener F-5a stock solution and 16 parts of water. The color and gradation of the finished print will not be affected by the use of this hardening bath. Remove the print from the hardener bath and wash it for at least 30 minutes in running water at 18 to 21°C (65 to 70°F).

For a packaged toner with similar characteristics, obtain KODAK Sepia Toner.

KODAK HARDENER F-5a

Water, about 50°C
(125°F) .600 mL
KODAK Sodium Sulfite (Anhydrous) 75.0 g
*KODAK 28% Acetic Acid235.0 mL
†KODAK Boric Acid, Crystals 37.5 g
KODAK Potassium Alum, Fine
Granular (Dodecahydrated) . . . 75.0 g
Cold water to make 1.0 L
Dissolve chemicals in the order given.

*To make approximately 28% acetic acid from glacial acetic acid, add 3 parts of glacial acetic acid to 8 parts of water.
†Crystalline boric acid should be used as specified. Powdered boric acid dissolves only with great difficulty, and its use should be avoided.

PROTECTIVE TREATMENT

Even when the last traces of hypo have been removed from a print by chemical means, the silver image is liable to attack by various substances in the atmosphere. The following solution will render the image more resistant.

KODAK GOLD PROTECTIVE SOLUTION GP-1

Water .750 mL
*Gold Chloride (1% stock solution) . . 10.0 mL
KODAK Sodium Thiocyanate
(Liquid) 15.2 mL
Water to make 1.0 L

*A 1% stock solution of gold chloride can be prepared by dissolving 1 gram in 100 mL of water. If gold chloride is not available locally, it can be ordered from Andor Chemical Corp., Drawer K, Southtown Station, Rochester, N.Y. 14623.

Add the gold chloride stock solution to the volume of water indicated. Mix the sodium thiocyanate solution **separately** in 125 mL of water. Then add the thiocyanate solution slowly to the gold chloride solution while stirring rapidly.

Procedure: Treat the well-washed print (which preferably has received a hypo-elimination treatment) for 10 minutes at 20°C (68°F) or until a just-perceptible change in image tone (very slight bluish black) takes place. Then wash for 10 minutes in running water and dry as usual.

Useful Capacity: About eight 20.3 x 25.4-cm prints per liter (thirty 8 x 10-inch prints per gallon). For best results, the KODAK GP-1 Solution should be mixed immediately before use.

Storage Conditions

In the past, many photographic collections were stored in unsuitable places, and the damaging effects of excessive heat and extreme dampness often went unrecognized until irreversible damage had occurred. Moreover, most photographs were, and still are, made without regard to their possible historic value. Very often, when files of negatives become inactive they are relegated to damp base-

ments, hot attics, or other equally unsuitable storage locations, and then the ravages of extremes of temperature and relative humidity may go unobserved and unchecked. Such neglect may result in the loss of important photographs or in the need for using special techniques that would otherwise not be necessary.

One of the greatest difficulties facing custodians of photographic collections is the sheer magnitude of the task. Many collections consist of hundreds of thousands of pieces. To deal adequately with the maintenance of such numbers of photographs is beyond the physical and financial capabilities of many institutions. A painful conclusion is inescapable, that some collections should be reduced to manageable proportions by careful selection of the best and most meaningful material. Otherwise deterioration will continue unchecked and the whole accumulation of pictures may be lost.

TEMPERATURE AND RELATIVE HUMIDITY

The moisture content of air must always be considered in relation to its temperature. The higher the temperature the greater the weight of water air can hold. At any particular temperature, the amount of water in the air, described as a percentage of the maximum that the air will hold at that temperature, is the relative humidity (RH). Absolute humidity is simply the weight of water per unit volume.

As a practical example, consider a warm summer day when the temperature is about 29°C (85°F) and the RH about 50 percent. Cooled in a basement to 20°C (68°F), air of the same absolute humidity would be very damp, having an RH of 83 percent.

A similar situation exists in a room cooled by an ordinary air conditioner, although an air conditioner extracts some moisture from the air by condensing water vapor on the cooling coils. For reasons associated with the operation of many types of air conditioners, the extraction of moisture may not be sufficient to keep the RH in a storeroom at a safe level. Dehumidifiers for home use are designed to reduce the relative humidity and are especially effective in cool, damp basements. See "Air Conditioning," on page 28.

Gelatin coatings, photographic paper, and film base absorb moisture from the air to a greater or lesser extent, depending on the nature of the material. A negative or a print surrounded by dry air will give up moisture to the air, while one surrounded by damp air will absorb moisture until a

balance, or equilibrium, is reached. The quantity of moisture held by a photographic material at equilibrium depends on the RH of the surrounding air. At a high RH—60 percent or more—the moisture content of a material reaches the upper limit of safety if physical damage and biological attack are to be avoided.

Limits of Relative Humidity. The desirable limits of RH in a storage room are 25 percent to 50 percent. In archival storage, these limits should not be exceeded, but in normal storage 20 percent to 60 percent can be tolerated, provided the condition is temporary. The dampness caused by high RH is much more damaging than the drying effect of low RH. The former can result in complete destruction of the records, whereas the latter will not.

Effects of Extremes of Relative Humidity. Dampness, or high RH, accelerates the effect of any residual processing chemicals that happen to be in the material and causes gelatin to become soft—sometimes to the point where it sticks to negative envelopes or anything else that may be in contact with it. High RH may cause irreversible size change, a particularly important matter in the storage of motion-picture films and black-and-white separation sets from color originals. There are always fungus spores in the air, and at RH values above 60 to 65 percent, they will germinate and the fungus will spread. In a humid atmosphere, gelatin in contact with any very smooth material, such as plastic negative enclosures, becomes glazed; see page 31. Dampness may eventually destroy paper, mounting board, and packaging material used in storage.

The effects of dryness, or low RH, are not very serious unless the condition prevails for several weeks at a time. RH below 25 percent may result in brittleness of film and paper, as well as excessive curl. Acetate film will shrink markedly if stored in a dry environment. However, this effect is usually reversible, and the size may be recovered on rehumidifying. Gelatin tends to become brittle in very dry conditions and it may leave the support in flakes. This effect is most often seen with old glass plates. Also, mounting boards tend to curve under low RH conditions.

For details about dehumidification and humidification of air, see "Air Conditioning," on page 28.

Storage Temperature. Generally speaking, temperature is not so critical as relative humidity, but as stated before, the two conditions must be consid-

ered in relation to one another. Temperatures exceeding 24°C (75°F) coupled with RH greater than 60 percent are the most damaging of all conditions, but a higher temperature can be tolerated for a considerable time if the RH remains less than 40 percent. *The foregoing remarks do not apply to the storage of films on cellulose nitrate base, because the rate of decomposition of this material approximately doubles with each 6°C (10°F) increase in temperature.*

Low temperature is not damaging in itself, in fact a storage temperature of 10°C (50°F) is preferable to one of 21°C (70°F) if the relative humidity can be controlled in a simple way; unfortunately, it rarely can be without using special air-conditioning equipment. In a small storeroom, a dehumidifier can be installed, but a daily check on the RH is necessary to be sure that the condition is within proper tolerances.

LIGHT

Any small amounts of light that might reach black-and-white materials in storage are not a factor in deterioration. Light has no significant effect on the silver of an image in any ordinary circumstances. However, constant exposure to light yellows gelatin and tends to make it brittle. Paper also yellows with exposure, but any considerable discoloration is more likely to be caused by oxidation or by the decomposition of silver thiosulfate residues retained in the paper structure. Valuable prints that are placed on display should, therefore, not be exposed to strong daylight for any length of time. Tungsten light is preferable to most types of fluorescent light for display purposes.

AIR PURITY

Pure air oxidizes paper, acetate film, and other photographic materials only at a very slow rate if the temperature and relative humidity are normal. Some chemical impurities in the materials themselves or in the surrounding air may accelerate the oxidation process in proportion to the amounts of such impurities that happen to be present. Today, one of the serious problems in preservation is the relatively large quantities of oxidizing gases in the atmosphere in certain areas.

The problem is, of course, most acute in areas of dense population where traffic is heavy and industry is concentrated. Coal-burning industry, gasoline and diesel engines, oil- and gas-burning heating systems, and industries employing chemical pro-

cesses all contribute to general air pollution. In addition, local areas of high pollution exist in the vicinity of busy streets and in areas where paints, lacquers, enamels, and varnishes are being used—automobile body shops and furniture factories, for example. There are many other such situations that are too numerous to describe here.

Oxidizing gases present in the air in greater or lesser concentrations according to the locality are hydrogen sulfide; sulfur dioxide; and to a lesser extent oxides of nitrogen, peroxides, formaldehyde, ozone, and others. If an alternative exists, the storage area should be situated as far from the sources of pollution as is possible. Otherwise, an air-conditioning system incorporating an air-purification device must be installed if the records are to be kept in good condition for as long as possible.

Near the seacoast, very small amounts of airborne salts and silica may find their way into storage areas and onto photographs. The salts, being hygroscopic, tend to establish a high level of moisture, which not only accelerates localized chemical activity but also encourages the growth of microorganisms.

Effects of Oxidizing and Acidic Gases. The severity of attack by various gases in the atmosphere depends on the concentration of the gases, or fumes, on the presence of residual processing chemicals in the materials, and on the levels of temperature and relative humidity. If there are residual chemicals present, moisture alone may precipitate their attack on an image. Since the effects of oxidation on a silver image are similar, regardless of the cause, it is difficult to determine in any particular case to what extent atmospheric conditions were responsible for the deterioration. In most cases, there is no single cause of fading and staining of a material; the effect is usually due to a combination of several factors.

The effect of oxidizing gases is usually to yellow and fade the silver of the image. The paper base of a print is also degraded and stained. A brownish yellow stain around the edges of a print that has been stored in an album is a sure sign of atmospheric deterioration. The characteristic effect with negatives is silver sulfide stain at the edges. This type of stain is apt to appear yellow by transmitted light but gray by reflected light, and hence is often called "dichroic stain." The deposit is generally heaviest at the edges of negatives, where air has been able to penetrate more easily than it did to the center of the negative. Acidic gases that are often present in the air tend to degrade gelatin, the paper base of prints, and the film base of negatives.

Detecting Gaseous Impurities in Air. A simple test has been devised that indicates the presence of damaging gases in the atmosphere of a storeroom, for example. This test is based on the time taken for a material coated with colloidal silver to darken upon exposure to oxidizing gases. See Weyde, E., 1972, A Simple Test to Identify Gases Which Destroy Silver Images, *Photographic Science and Engineering* 16:283-286.

FIRE PREVENTION

A great deal has been said about protecting photographs from deterioration by chemical agencies, but this kind of damage is relatively slow and it can be prevented or arrested if observed in time. Damage by fire and the water used to extinguish fire is usually sudden and total.

As far as possible, noncombustible materials should be used in the construction of the storeroom as well as for the fittings and fixtures. Fire prevention is particularly important when any considerable quantity of nitrate-base film is stored. For advice on the subject of fire prevention, consult the National Fire Protection Association, 470 Atlantic Avenue, Boston, Massachusetts 02210.

FLOOD AND WATER DAMAGE

Quite often, when fire breaks out, as much damage is done by the water used to extinguish the fire as by the fire itself. Sprinkler systems are a constant threat, since a faulty sprinkler may operate without being exposed to great heat. Consequently, storage containers should be capable of protecting the contents without being airtight. Under no circumstances should boxes or containers of photographs be stored on the floor. Such boxes and the lower drawers of filing cabinets must be raised at least 6 inches above the floor. Water pipes and drainpipes

Flash floods such as this occur without warning. Since there is no time to remove valuable articles from basements or ground floors, store perishable goods, such as photographs, out of reach of floodwaters.

should not pass through the storage area, because a leaky pipe could cause serious damage and it might go unnoticed for a considerable time.

Attics and basements should never be used for the storage of photographs. Large and comparatively rapid variations in temperature take place in an attic or any other place situated immediately below a roof. Also heavy rain and melting snow present a hazard if the roof should become leaky, a situation that may pass unnoticed until considerable damage has been done.

As stated before, the air in a basement is very often damp, but also there is an ever-present risk of burst water pipes, sewers that back up during a rainstorm, or flooding during heavy and prolonged rain. In some places, floods are seasonal and are expected, but in other places extraordinary weather conditions cause floods that cannot easily be foreseen. During 1972, several such floods occurred in the United States, and two collections of historically and commercially valuable negatives were extensively damaged. One, a collection of glass plates, was ruined; the other, consisting mainly of film negatives, was saved in part, but only at considerable expense. In places where flooding is even remotely possible, therefore, careful attention should be given to the location of the storage area. See "Treating Water Damage," on page 60.

CONTROL OF DUST

In the storage of photographs, the question of dust is often overlooked, but it is probable that some forms of deterioration can be attributed to reactive particles of various substances that become airborne and find their way into any but the most efficiently sealed containers. It would be difficult to determine if any particular spot or blemish on a print or a negative was caused by a particle of some kind, but since the possibility exists, some attention should be given to the filtration of air being distributed to the storage area. Aside from particles that might be chemically reactive, dust often contains abrasive material that might damage films. Also, fungus spores are associated with dust particles. Dust should therefore be controlled by filtering the incoming air. Large particles are trapped by ordinary air filters if the filters are kept clean and changed frequently; smaller particles, such as those in tobacco smoke, are not.

People are also responsible for significant amounts of dirt. They track it into a room and move it about as they move. Further, they shed lint from their clothing and particles from their hair and skin. Good housekeeping will minimize dirt from these sources. Smoking, eating, and drinking should be prohibited in a storage area.

Courtesy of International Museum of Photography.
Her Majesty Queen Victoria of England. 1861 Daguerreotype by Mayall.

Air Conditioning

When atmospheric conditions in the storeroom cannot be maintained within the recommended tolerances of temperature and relative humidity, some form of air conditioning should be installed. For the purpose of this discussion, air conditioning means the use of any appliance to cool, humidify, dehumidify, or clean the air.

An appliance employing a water tank for any purpose must be kept clean to prevent the formation of biological slime that may decompose to produce hydrogen sulfide.

HUMIDIFICATION

Humidification is rarely necessary unless the relative humidity in the storeroom falls below 15 percent for extended periods. This condition may occur during a spell of very cold weather when the incoming air is heated. If the heating system does not include a means of humidifying the air, a separate automatic humidifier should be installed in the storeroom and the humidistat set to maintain a relative humidity of about 40 percent. Since the humidity control on such appliances is not usually calibrated in terms of relative humidity, the value should be checked with a sling psychrometer or a wet-and-dry-bulb thermometer. To avoid the somewhat time-consuming operation of using a sling psychrometer, a good-quality hair hygrometer can be used instead if it has been checked against the more accurate instrument.

A humidifier can be replenished with water manually, or the water level can be kept constant by piping the water supply to the appliance and using a float valve to control the water level. However, this method entails some risk of flooding, because a sticky float valve may fail to shut off the water. For trouble-free operation of a humidifier, always keep it clean and free from the calcium deposits left by the evaporation of water.

Trays or other vessels of water or chemical solutions are not recommended for humidification because of the risk of overhumidification.

DEHUMIDIFICATION

In situations where the temperature remains at 10-16°C (50-60°F) for long periods, the relative humidity is likely to be 60 percent or even higher. Such conditions exist in basements, caves, or in the

This is a photograph of the back of a cardboard mount that had been in contact with a sheet of plywood for a number of years. Products from the wood have migrated to the mount and produced this stain pattern.

lower part of large stone buildings. Remember that the use of a basement is not recommended, although it may be unavoidable in some circumstances. When the relative humidity approaches the acceptable maximum, a dehumidifier is necessary. An electrical, refrigeration-type dehumidifier controlled by a humidistat is the most suitable unit. The condensate should be piped from the unit to a drain carrying it outside the room; otherwise, constant attention is needed to avoid the risk of overflow.

The use of silica gel or other desiccants is not recommended for permanent installations unless there is no alternative. Dessicants create the risk that fine dust, either abrasive or reactive, may come in contact with the stored material. Also, they require constant renewal or treatment. However, silica gel can be used to protect a small quantity of material from dampness if no other means of dehumidification is available. Such an occasion might arise when a quantity of negatives is transported from one location to another in a very damp climate.

CONDITIONING EQUIPMENT

Although appliances for adding moisture to or extracting it from the air are useful in many cases, the most satisfactory system is complete air conditioning with equipment that is capable of maintaining the proper levels of temperature, relative humidity, and freedom from contaminants. This equipment is necessarily expensive, but in any

situation where the photographic material is sufficiently valuable, the cost is justified.

The following discussion about air conditioning is of a general nature; it cannot take the place of advice by an air-conditioning engineer. Such advice is essential, because conditions vary greatly and because it is vital to install a unit with the proper capacity and with features that meet all the requirements of the particular situation.

Window, or household, units are not very suitable for the storeroom. One reason is that they must be vented to the outside of the building and then preferably on a north-facing or well-shaded wall. Although these units extract some moisture from the room air, they do so mainly when the compressor is operating. When the compressor shuts off automatically at a preset temperature, the fan continues to run and then moist air is blown back into the room over the wet cooling coils. The practical significance of this situation is that the relative humidity in the room may rise above the desired value. If, for any reason, a portable air conditioner must be used, choose one that does not have a much greater cooling capacity than the size of the room demands. The compressor will then operate for longer periods than it would if the unit had much greater capacity than needed to cool the area. In any case, check the relative humidity and if it is consistently too high, install a dehumidifier as well.

Whatever type of air-conditioning unit is decided upon, it must be capable of maintaining both relative humidity and temperature within specified limits throughout the year. An upper limit of about 20°C (70°F) with RH between 20 and 50 percent is satisfactory for black-and-white materials. Where considerable quantities of nitrate film base are stored, a lower temperature, 10°C (50°F), is desirable, and the upper limit of relative humidity must not be exceeded. A lower limit not lower than 20 percent is desirable; otherwise, the film base may become too brittle, although this risk is not so important with single negatives as it is with motion-picture films.

Excessively low relative humidity is generally not a problem in conditioning air at relatively low temperature. On the other hand, maintaining an acceptably low RH with air that has been cooled to 10°C (50°F) or lower is a more difficult matter, and the initial cost of suitable machinery is high. This is not only because extra cooling capacity is needed, but because a second stage of cooling and reheating is required to remove moisture from the air. In the interest of economy, therefore, the upper limit of temperature should be as high as can be tolerated by the material being stored.

For archival storage of negatives and prints, the limits of temperature and relative humidity given here are necessary. However, when economy in air-conditioning equipment is important, the limits can be relaxed to some extent, provided that an RH exceeding 60 percent does not prevail often or for more than a few days.

A slight positive pressure should be maintained within the storeroom to prevent the entrance of untreated air. The air conditioner should preferably be located outside the storage area for ease of maintenance, inspection, or repair in case of breakdown. The unit should be of high quality to make frequent repair or replacements unnecessary. All ductwork as well as the conditioner housing should be insulated. Ducts carrying air from the unit or out of the storeroom should have automatic fire-control dampers.

Storage Materials

A number of materials often used in the storage of negatives and prints are detrimental to the image and its support. Unfortunately, the choice of containers and packaging materials is limited, and there is no easy way to determine whether or not a material is suitable for long-term storage unless it has an extensive history of stability.

The following suggestions are based on the best knowledge available at the time of printing, but no assurances can be given, because manufacturers may change their formulations without informing the public. Accelerated tests may provide a guide, but they cannot always be related meaningfully to long-term keeping. Photography is a relatively young science, and 100 years is more than half its life. Experience with long-term keeping is thus limited. Moreover, there is a tendency to apply experience with paper used in making books and ledgers to the photographic case, and without supporting evidence such experience may not apply. For instance, nonacid papers made for book archives may have an alkalinity that promotes increased life for books, but that may well be suspect with photographs, especially color prints.

UNSAFE MATERIALS

Among the materials known to be detrimental to photographs are wood and wood products, such as

plywood, hardboard, chipboard, and the like, low-grade paper, glassine, and strawboard. Also detrimental are nitrated and formaldehyde-based plastics, polyvinylchloride, and acrylics, including acrylic lacquer and acrylic enamel. These materials contain plasticizers, solvents, and residual catalysts that volatilize. Damage to photographs is greatest when they are in direct contact with these materials, but damage also occurs when the volatile elements contaminate the air in the immediate vicinity or in enclosed containers. Other sources of trouble in storage are rubber, rubber cement, and hygroscopic adhesives or those containing iron, copper, sulfur, or other impurities. Pressure-sensitive tapes and mounting material, as well as acid inks and porous-tip marking pens that use water base dyes should also be avoided.

The substances just mentioned can, singly or in combination, cause staining and fading or other degradation of photographs. The severity of these effects depends largely on atmospheric conditions in the storage area and on the amounts of residual processing chemicals in the photographs. Consequently, it is difficult to determine the effect of any one agent by itself without reference to all the others. Therefore, to be on the safe side, the archivist must adopt an uncompromising attitude in selecting storage materials for valuable records.

RECOMMENDED MATERIALS

From the foregoing, it will be seen that the number of materials that can be used with safety is limited. These include steel with baked-on synthetic enamel coating, anodized aluminum, and stainless steel for shelves, filing cabinets, and storage boxes. High alpha-cellulose paper is safe if it meets the requirements of the American National Standard Requirements for Photographic Filing Enclosures for Storing Processed Photographic Films, Plates, and Papers, ANSI PH1.53-1978. Enclosures and interleaving sheets made from cellulose acetate with no surface coating can be used with paper prints, provided the material has been made with not more than 15 parts of plasticizer per 100 parts ester. Polyethylene terephthalate (polyester sheeting) can also be used as an interleaving material for paper prints.

Mounting boards should be made from acid-free high alpha-cellulose stock, and prints should be mounted with dry-mounting tissue. Heat sealing and mechanical sealing are preferred if the material permits. Experience so far indicates that well-buf-

fered polyvinyl acetate adhesives can be used with paper.

Heat-sealable envelopes made of 0.0127-mm (0.0005-inch) aluminum foil extrusion coated with pure polyethylene on the inside and laminated to a pure paper on the outside can be used as a sealed container. This type of envelope is similar to those used to enclose unexposed film. Such envelopes are supplied as KODAK Storage Envelopes for Processed Film, 4 x 5 and 8 x 10. They are valuable if the contents are not often displayed or used, or when high relative humidity cannot be controlled. Annealed, heat-cleaned aluminum foil can be used as an outer wrapping for batches of prints.

Negatives and prints can be wrapped in, or interleaved with, the paper used by the manufacturer in packaging unexposed photographic films and papers. This paper has been specially prepared to have no effect on the sensitized materials.

NEGATIVE ENCLOSURES

The question of negative enclosures has always been a vexed one, because among those available very few are entirely suitable. The choice is limited to paper envelopes, cellulose acetate sleeves, and polyethylene bags. Each is discussed in the following subsections, so that the user can choose the one that best suits his particular needs.

Paper Envelopes. The best quality paper is known to be a stable material over long periods, and it contains no ingredients that will affect a negative in storage. However, the choice of the paper stock from which the envelope is made is very important.

At one time it was thought that all-rag paper was the only material that could meet the standards of purity necessary for long keeping. Today, purified wood pulp papers with essentially the same characteristics as stable rag paper are available. These are acid-free high-alpha-cellulose papers that are buffered against changes in pH.

Two very critical aspects of paper envelopes are the position of the glued seam and the adhesive used to seal it. Most older envelopes were made with the seam in the center, and it was usually sealed with a hygroscopic animal or vegetable glue. As a consequence, the glue absorbed moisture from the air, which caused a band of stain to form across the negative in a position corresponding to the seam of the envelope. Buckling may also have occurred, due to pressure at the seam. The adhesive used to

manufacture the envelope should, therefore, be nonhygroscopic and nonreactive. Polyvinyl acetate appears to be a suitable adhesive, but natural glues, pressure-sensitive adhesives, and ether-linked materials are not.

Semitransparent glassine envelopes should not be used in long-term storage, because some of the materials used in their manufacture may affect image stability. Also, the envelopes become brittle with age and may disintegrate. Kraft paper envelopes and any other envelopes made from low-grade materials may oxidize and form acids or traces of peroxides from the lignin, which will degrade any other material that comes in contact with them.

Cellulose Acetate Sleeves. These transparent enclosures have the advantage of allowing negatives to be handled and viewed without removing them. KODAK Sleeves are supplied in a range of roll- and sheet-film sizes.

While the acetate material is as durable as film base itself, the glossy surface may cause ferrotyping, or glazing, of the gelatin surface of the negative.

There is a transmission differential between the glazed patches and the rest of the negative, which produces density variations in a print from the negative. Glazing generally occurs in conditions of high relative humidity, but if the negatives enclosed in sleeves are under pressure, glazing occurs at a relative humidity that would not be considered as high for normal storage.

Although acetate sleeves are used extensively in the photographic trade, and their use is generally satisfactory, good-quality paper envelopes are preferred for long-term storage.

Polyethylene Bags. So far as is known, no deleterious chemical reactions take place when polyethylene enclosures without surface coatings are used with negatives. However, glazing can occur when the negative and the polyethylene are under pressure. One possibility of trouble exists in the use of polyethylene enclosures: if a fire occurred in the immediate vicinity of the storeroom, heat that would not destroy negatives on acetate film base, nor even scorch good-quality paper, might melt polyethylene and thereby damage the negatives.

George Eastman with a Kodak camera on board S.S. Gallia. 1890 photograph by Fred Church.

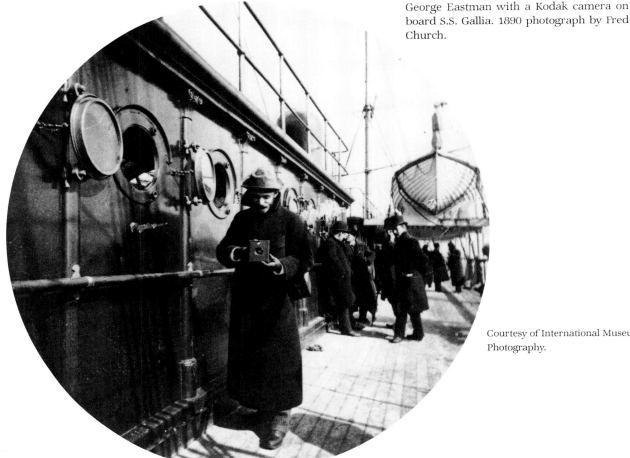

Courtesy of International Museum of Photography.

Storage of Films and Plates

This section is concerned with recommendations for storing negatives; see also American National Standard Practice for Storage of Processed Safety Photographic Film, PH1.43-1976, and American National Standard Practice for Storage of Processed Photographic Plates, PH1.45-1972. The special considerations applying to nitrate negatives are discussed in the next section.

FILMS

When black-and-white negatives on acetate or polyester film base are processed properly, and are protected in storage from the effects of heat, moisture, oxidizing gases, and reactive storage materials, they are extremely stable articles. They will outlast most other photographic records and, since they can be duplicated with very little loss of quality by a comparatively simple process, they constitute the best material for archival purposes.

Normal Storage of Negatives. In temperate climates, air conditioning in the storeroom is not essential for normal storage of negatives, but it is desirable.

Storage Conditions. A temperature of about 21°C (70°F) with a relative humidity between 30 and 50 percent is suitable. To provide uniform humidity in drawers and cabinets, they should be ventilated. Ventilation should also be provided in the storeroom, and incoming air should be filtered to remove as much dust as possible. In large cities, particularly those in which iron and steel are made, the air may contain relatively large amounts of sulfur dioxide and other gases; consequently, some means of cleaning the air in a storeroom is recommended.

Archival Storage of Negatives. Acetate and polyester film negatives of archival value should have a fire-resistant vault for protection against outside fire. Any openings in the walls for ventilation or air conditioning should be protected by suitable fire-control dampers. Sprinklers are not recommended, but automatic carbon-dioxide fire-control systems are desirable. Generally, the vault should be constructed and equipped according to the recommendations of the National Fire Protection Association.

Air Conditioning. In situations where air conditioning is necessary, the most practical aims for temperature and relative humidity are 10 to 16°C (50 to 60°F) and RH between 30 and 45. Although a lower temperature is desirable, it becomes costly to control RH at temperatures much lower than 10°C.

In locations where atmospheric contamination is severe, consideration should be given to relocating the records in another place where the air is purer. Otherwise, some form of air purification is necessary.

Duplication of Records. In dealing with very valuable records of any kind, one of the best safeguards against total loss is to make duplicates and store each set of records in a different place. In preserving microfilms, this is a normal procedure, but with ordinary photographic negatives, the production of duplicates is not such a routine matter. However, making duplicate negatives today is a less complicated procedure than it used to be. See "Duplicating Negatives," on page 48.

PLATES

The same storage conditions apply to glass plates as for acetate and polyester films. Glass is the most stable of the materials used as supports for photographic images. The problems in the storage of plates are their weight, bulk, and fragility. Since most plates are comparatively old, they may show some signs of deterioration in the form of yellow stain and silver sulfide deposit, or dichroic stain, particularly around the edges of the negatives, where air has been able to penetrate the packaging. Many glass negatives have been stored in the original boxes used to package the unexposed material. Very often, individual envelopes were not used, and the plates were stored without any protection other than the boxes. This situation favored the formation of silver-sulfide stain around the edges of the plates. This type of stain is largely a surface deposit, and it can be partially removed by polishing or it can be removed by chemical treatment, whichever seems the more suitable approach. See "Silver Sulfide and Silver Stains," on page 52.

Negatives on Nitrate Base

The tendency of nitrate film base to decompose on aging and the factors that affect such degradation were discussed in the first section of this book. Also, nitrate film base poses a serious fire hazard. Nitrate negatives should therefore be segregated and stored under the best conditions available until they can be duplicated and the originals destroyed.

IDENTIFYING NITRATE BASE

Unless some deterioration has set in, it may not be readily apparent whether film is on nitrate or acetate base. Generally speaking, any negatives that were made before 1950 are suspect, although many negatives were made on film with an acetate base long before that time. Kodak sheet films are readily identifiable by the words "Kodak Safety Film" printed along one edge near the code notch, but many films of other manufacturers bear no such identification.

The following table shows when Kodak films of various types, originally on nitrate base, were changed over to acetate base. Note that 16-mm and 8-mm movie films were never made on nitrate base.

Type of Film	Year of Last Nitrate Film Manufactured by Kodak in the U.S.
X-ray films	1933
Roll films in size 135	1938
Portrait and commercial sheet films	1939
Aerial films	1942
Film packs	1949
Roll films in sizes 616, 620, etc	1950
Professional 35-mm motion-picture films	1951

One indication of the presence of cellulose nitrate is a characteristic acid odor. This odor is usually present when a quantity of nitrate film has been packaged in a closed container.

Float Test. A test to distinguish nitrate base from any of the acetate bases is to take a 6-mm (¼-inch) square piece of dry film and place it in a test tube containing trichloroethylene. Shake the tube to make sure that the film sample is completely wetted.

If the sample sinks, it is cellulose nitrate; if it floats, it is acetate or polyester. Although trichloroethylene is not flammable, it is volatile and the vapor should not be inhaled. Trichloroethylene is obtainable from most suppliers of laboratory chemicals.

EVALUATING EXTENT OF DETERIORATION

It should not be assumed from this discussion that all negatives on nitrate base are on the verge of total loss. If they are properly cared for, they can be expected to last for a considerable number of years. It is important, however, to recognize the first signs of decomposition. First, the film base becomes yellowish and then amber. At this stage the base is brittle and it breaks easily on being bent double. Also, the gelatin has become soft enough to melt readily if the negative is wetted. To make a simple test, cut a small strip from the clear margin of a negative, fold it to check for brittleness, then soak the strip for a minute or so in water. Scrape the gelatin from the surface. The degree of discoloration can then be observed by placing the strip on a sheet of white paper. This procedure is necessary in order to discover the degree of discoloration of the film base, because most old negatives appear to be slightly yellow due to sulfiding of traces of silver in the emulsion and to some yellowing of the gelatin itself.

Clearly, negatives in the process of decomposition must be handled with care and kept dry. Also, they should be duplicated as soon as is convenient. In the later stages of decomposition, which takes the form of buckling and stickiness of the gelatin, duplication becomes much more difficult. See "Nitrate Base Negatives," on page 49.

SPONTANEOUS COMBUSTION

In the days when motion pictures were made on nitrate-base film, many fires occurred due to spontaneous ignition of this material. So far as is known, fire has not been caused by cellulose nitrate in good condition, but in the advanced stages of decomposition, self-ignition can take place at temperatures greater than 38°C (100°F) if they are sustained for a considerable time.

The conditions under which still-picture negatives on nitrate base would ignite spontaneously are rare, but the possibility, however remote, does exist. Generally, self-ignition of the material has been caused by sustained high temperature coupled with low relative humidity, and where the heat generated

by the process of decomposition was unable to escape. Moreover, a considerable amount of material would need to be in a closed container to make spontaneous ignition possible. Tests have shown that a 1000-foot roll of decomposing motion-picture film ignited after being subjected to a temperature of 41°C (106°F) for 17 days. The film was enclosed in a can wrapped in mineral wool to retain the heat generated by the process of decomposition.

TEMPORARY STORAGE

Examine all negatives known to be on nitrate base. If any are badly buckled or sticky, they are in an advanced stage of decomposition. It may be possible to duplicate some of these, or if duplication is not feasible in the circumstances, they often yield a fair quality print. If the film base is heavily stained and moisture from the breath makes the gelatin slightly sticky, the negatives must be duplicated within one or two years. In any case, put each negative in a good quality paper envelope and discard the old enclosure. Remember to transfer any information that may be on the old envelope to the new one.

On no account wet a nitrate-base negative with water, because the gelatin may be soft and readily dissolved if the film has decomposed. If surface dirt must be removed, use KODAK Film Cleaner. Many old negatives have some dichroic or silver sulfide stain; this iridescent stain is usually on the surface of the gelatin, and it may be removed or reduced by rubbing the negative with *DuPont* White Polishing Compound, which is obtainable from most automotive supply stores. Put a small amount of the compound on a piece of cotton wool and rub the negative gently until the deposit has been removed. Be very careful not to damage the image. Also be careful not to bend the negative, because the base is usually very brittle and easily broken.

Storage Conditions. The following instructions are intended for the storage of negatives until such time as they can be duplicated on a more stable film. Note that the instructions are for small quantities of material only. Large quantities should be stored in vaults that meet the specifications of the National Fire Protection Association.

Nitrate base material should not be stored in closed containers without ventilation, because the products of decomposition cannot escape and they increase the rate of decomposition. The negatives should be packed loosely in ventilated metal boxes or cabinets and stored in a room apart from other negatives or photographic materials.

The temperature in the storage area should not exceed 21°C (70°F), and a lower temperature is desirable if it can be achieved without increasing relative humidity above 45 percent. From the standpoint of retarding decomposition, RH below 40 percent is desirable, but there is a risk of negatives becoming very brittle if conditions are too dry. With the nitrate-base material, RH is critical, because a compromise must be reached between making the base too brittle and making the gelatin so tacky that it might adhere to the negative enclosure. For the control of RH, see page 24.

DISPOSAL

When negatives on nitrate base have been duplicated, they should be destroyed. Only small numbers of films *in good condition* can be discarded into normal trash-disposal channels. Do not incinerate nitrate negatives with office wastepaper.

Unstable or deteriorated nitrate films present hazards similar to explosives and must be handled with the same respect. Such films should be kept *under water* in a suitable steel drum until disposal can be arranged. Any substantial quantity of films should be regarded as unstable, whatever its apparent condition.

The safest method of disposing of nitrate films is by carefully controlled burning by qualified personnel in the open air. In most cases, environmental or fire-prevention regulations will require that such disposal be supervised by the proper authorities. A large area removed from any building or combustible material, such as gases, brush, or litter, should be selected, and only a small quantity of film burned at one time. Nitrate films should never be burned in a furnace or other enclosed space, because the gases generated by burning produce high pressure and are highly toxic as well. However, if buildup can be prevented by controlled-rate feeding, it may be possible to dispose of nitrate film in a good incinerator equipped with pollution-control devices.

Paper Prints

Unlike negatives, which can be stored under good conditions most of the time, prints are often displayed. Indeed, part of the value of a print may lie in its being a worthwhile exhibit. A print may be valuable because it is considered to be a work of art or simply because it is the only representation of a particular subject in existence. In either situation, it must be protected during display and during the

handling that display entails. See also American National Standard Practice for Storage of Black-and-White Photographic Paper Prints, ANSI PH1.48-1974.

MAKING PRINTS FOR EXHIBITION

The following suggestions are intended for those who make their own prints or can set specifications in ordering prints from a supplier.

Size. Although size is a matter of individual preference, prints should usually not be too large; first, because large prints are more easily damaged than small ones, and second, because small or medium-size prints are easier to store, particularly if they are mounted on boards of uniform size. Many custodians favor prints not larger than 28 by 36 cm (11 by 14 inches.) A generous margin around the image will minimize the danger of its being damaged by handling.

Exhibition prints may be made specifically for the purpose, or prints from a file may be prepared for exhibit. In either case, the extent of the effort to be put into processing for stability is dictated to an important degree by the estimated future usefulness and value of the prints. Also, when existing prints are involved, especially old ones, consideration must be given to their present value and the risk of damage if additional processing is undertaken to prepare them for exhibition.

The sections "Processing for Stability" and "Print Stability Procedures," on pages 9 and 18, respectively, provide detailed processing information. It must be an individual decision, based on available funds and other circumstances, whether to remove the last traces of hypo, treat with Gold Protective Solution, tone the image, or use some combination of these treatments.

Again, valuable material should not be treated in any way that involves soaking the print, because there is always a risk of damage in such treatments. Frequent handling may cause loss or damage. If it is desired to make a more permanent print from one that already exists, a copy negative should be made from the original, and then new prints from the negative can be treated as desired.

MOUNTING

Dry mounting tissue is recommended for mounting prints. Starch paste, animal glue, and rubber cement should not be used. Some synthetic adhesives could be used for mounting small prints, but dry mounting is preferable for all sizes, because the adhesive tissue provides a barrier between the mount, which might contain impurities, and the print itself. Of course, this advantage is lost if prints are stacked in files where the back of one mount board touches the face of the next print. Interleaving of prints is recommended, whether they are mounted or not.

Some custodians prefer not to mount prints that are to be stored for long periods. They reason that unmounted prints occupy less space and involve fewer materials that might prove deleterious to the images. Also, unmounted prints can be reprocessed, if it should become necessary, without the need to remove them from mounts.

Mounting Board. The use of high-quality mounting board is essential to the long-term keeping of a print. Therefore, mount stock of unknown quality and uniformity should not be used. To be considered for this purpose, any paper product should be free of groundwood, alum, or alum-rosin size and have a pH of about 6.5.

Borders. Examination of many old photographs indicates that those mounted with wide borders on the mount often suffer less from atmospheric deterioration than those with narrow borders. For this reason, it is desirable to mount prints with borders about 8 cm (3 inches) wide at the top and sides, and about 9 cm (3½ inches) wide at the bottom. Since mounts are often damaged in handling, the wide borders allow for some trimming of damaged edges.

Overlays. A hinged overlay that covers the print and mount affords some protection from contamination by atmospheric gases or by materials that might otherwise come into contact with the print (including other prints, whether mounted or not).

Prints that are handled frequently should be protected with a sheet of transparent material. Suitable plastic sheets for the purpose are cellulose acetate and polyethylene terephthalate, both without surface coating.

Lacquers. Print lacquers provide physical protection from fingerprints and act as a moisture barrier. The use of a lacquer will also help prevent the emulsion of a print from sticking to glass or a material used as an overlay or for interleaving. Since lacquer formulations vary, only a lacquer designed for photographic applications should be used.

Frames. Prints that are to hang on a wall can be framed in the usual manner, but a cardboard matte should be used to separate the print from the glass. Otherwise, ferrotyping of the print surface may occur, particularly in humid conditions, or if condensation forms on the glass when the frame hangs on a cold wall.

Wood frames, especially those made of bleached wood, may cause problems, but it is difficult to avoid their use. In any case, varnished or oiled frames should be avoided. Aluminum frames are good.

If a frame has a backing made of plywood, as is sometimes the case, discard the plywood and replace it with a sheet of high-quality mounting board, because raw wood contains oxidizing agents and other substances that will stain the mount and, in time, will affect the print as well.

EFFECTS OF LIGHTING

Black-and-white prints that have been processed properly suffer little from the effects of exposure to light for moderate periods. Some yellowing of the gelatin and the paper base will take place if the print is displayed under light sources rich in ultraviolet radiation, such as fluorescent tubes or direct daylight. Tungsten illumination is preferable, but any light used for display should be no more powerful than is necessary to provide adequate viewing conditions. As mentioned earlier, sulfide-toned images are more resistant to atmospheric contaminants than those composed of metallic silver. Where circumstances permit, sepia-toned prints should therefore be used for display.

President Abraham Lincoln. 1860 Daguerreotype by Hesler.

Reproduction by courtesy of International Museum of Photography.

STORAGE OF PRINTS

In general, the storage of prints requires the same conditions as acetate- or polyester-base films. Photographic prints with metallic silver images are subject to attack by residual processing chemicals retained in the paper, by unfavorable conditions of temperature and relative humidity, and by oxidizing gases in the atmosphere. The presence of residual chemicals accelerates the action of other destructive agencies.

Examination of aged material indicates that paper prints are somewhat less durable than negatives on acetate or polyester base. There are some probable reasons for this difference. One is the difficulty in washing the fibrous structure of paper free from the last traces of silver and hypo compounds that decompose in time. Another is the fact that paper has a greater propensity than film base for absorbing moisture from the air. Also, prints often come in contact with other material, such as interleaving paper, mounts, and wrappers of various kinds, any of which may contain reactive impurities that affect the prints.

Storage Materials. Prints should not be stored for long periods in wooden boxes or wooden filing cabinets, nor should they be kept in boxes made from cardboard, except those made especially for this purpose. Cabinets and other containers made

from wood or wood pulp contain noncellulose materials, such as lignins, waxes, and resins. These materials oxidize or break down in time to produce acids and other substances that migrate to any material that is in their immediate vicinity. Moreover, peroxides released by the bleached wood often used for storage cabinets, as well as residual solvents from varnishes, can cause substantial damage to photographic prints. Fireproof containers such as enameled steel, stainless steel, or anodized aluminum are preferable, and they may be necessary to meet fire regulations for the storage of valuable records.

Do not store prints in contact with one another or in contact with the backs of the boards on which other prints are mounted. Interleave each piece with high-quality paper or transparent plastic sheets made from uncoated cellulose acetate or polyethylene terephthalate. Some types of plastic material commonly available, such as polyvinyl-chloride, should be avoided.

Atmospheric Conditions. Temperature should not exceed 21°C (70°F) and relative humidity should be within the range between 30 and 50 percent. For details, see "Temperature and Relative Humidity," page 24; "Air Purity," page 25; and "Control of Dust," page 27.

Preserving Color Photographs

For the purpose of this discussion, a color photograph can be defined as a color image that was produced chemically during the processing of the photographic material. Hand colored photographs and those made by lesser known processes are not included.

Over comparatively recent years, the use of color photographic materials has increased to the point where the majority of important photographs are made in color. Consequently, the keeping properties of these photographs has become very important to photographers, archivists, and others who must preserve color images as historical, sentimental, or commercial records of value.

Unlike black-and-white photographs, which are made up of metallic silver densities, color images are made up of dyes and like all other dyes these change with time; a condition that usually results in changes in density, or color, or both. Fortunately, however, the rate of change can be reduced by

several means as will be discussed later. Moreover, the rapidly advancing technology of color photography has resulted in some more stable dyes than have been available hitherto.

DYE STABILITY

The change, or fading, of dyes results from a group of complex chemical reactions that accelerate under high temperature, high relative humidity, atmospheric pollution, or a combination of these factors. The manufacturer, the processor, and the user of color photographic products can all affect significantly the rate at which dyes fade in a color photograph.

MANUFACTURING FACTORS

When a manufacturer designs and builds a color film or paper he can influence image stability by the selection of dyes, other ingredients of the emulsion layers, and the steps and ingredients of the recommended process. In designing a color photographic product and its associated process, the manufacturer must make compromises in selecting dyes so that they meet a number of aims only one of which is image stability. Among the factors that must be considered are the toxicity of the chemicals, cost of materials, reactivity of dyes, color of dyes, compatibility among dyes, compatibility of dyes with the selected process, and the cost of that process. Clearly, this is not a simple matter, but Eastman Kodak strives to produce color products with the best possible stability while meeting other essential requirements as well.

PROCESSING FACTORS

Processors of color photographs can, by following the manufacturer's processing recommendations, provide the user with pictures having the best image stability of which the materials are capable. In some situations, failure to follow the processing recommendations can impair the image stability of color photographs.

FACTORS IN USE OF COLOR PHOTOGRAPHS

By their treatment of processed color photographs, users can influence image stability by an enormous amount. In fact, a user can select conditions that may assure a useful life in excess of 100 years for almost any properly processed color photograph made on a Kodak product. Basic information on the storage and

care of color photographs is contained in Kodak Publication No. E-30, *Storage and Care of KODAK Color Photographs.* For the most up-to-date information, be sure to read the latest printing of this publication.

Aside from manufacture and processing, the factors that a user can control and that affect color image stability are discussed in the following paragraphs. These factors are exposure to light, storage temperature, storage relative humidity, and contamination by certain gases or other reactive materials.

Exposure to Light: Photographs are displayed, examined, and used in a great variety of ways, and so are exposed to many different light sources and light intensities. All dyes deteriorate when exposed to light, particularly when exposed to light of high intensity, or for a long period, or both at the same time. Those who are interested in preserving color images for a long time should avoid these conditions as far as possible. If valuable color pictures are to be displayed or projected frequently, make duplicate prints or transparencies and display these while the originals are kept under the best storage conditions. Thus, the originals are exposed only to the minimum amount of radiation necessary to make the duplicates.

Effect of Temperature: As with many other chemical reactions, dye fading proceeds at a reduced rate at low temperatures as indicated by the following table, which gives relative fading rates at 40 percent relative humidity.

Effect of Temperature on Dye Fading Rate (40% relative humidity)

Storage Temperature	Relative Fading Rate*	Relative Storage Time*
30°C (86°F)	2	1/2
24°C (75°F)	1	1
19°C (66°F)	1/2	2
12°C (54°F)	1/5	5
7°C (45°F)	1/10	10
–10°C (14°F)	1/100	100
–26°C (–15°F)	1/1000	1000

*These values do not apply exactly to all color photographs, but they are close enough for most practical purposes.

Low-Temperature Storage: Storage of photographs at low temperatures requires the use of a refrigerator, freezer, or other kind of refrigerated chamber. Usually, the relative humidity is high in these circumstances and so special moisture proof packaging is necessary. Suitable storage envelopes are made from polycoated aluminum and paper (KODAK Storage Envelopes for Processed Film). These envelopes can be heat sealed to exclude moisture. An alternative is to use three wraps of household aluminum foil with the seams and folds taped with moistureproof tape, such as plastic electrical tape. The effectiveness of both of these methods depends, of course, on the integrity of the seals. Before sealing the packages, the separated films, interleaving material, all enclosures, and the storage envelopes must be preconditioned for at least an hour in a small room or chamber at a temperature of about 21°C (70°F) with a relative humidity between 25 and 30 percent. Carry out the insertion of the films in the envelopes and the sealing operation in the same air conditioned chamber. The packages can then be placed under refrigeration. Note that one or more refrigeration-type dehumidifiers may be needed to achieve the necessary low humidity.

Effect of Humidity: Dye fading generally proceeds at a lower rate at lower relative humidity than it does at high relative humidity. Thus dye fading in color photographs can be retarded by storage at low relative humidity—the most appropriate value for long-term storage is between 25 and 30 percent. This condition is met by the preconditioning and sealing method described in the foregoing paragraph.

The following table compares the approximate relative fading rate of yellow dyes in some Kodak products at 15, 40, and 60 percent relative humidity. Yellow dyes are chosen for this example because they are generally more sensitive to relative humidity changes than cyan or magenta dye, but this is not invariably so. The table also shows the relative increase in storage time that can be achieved at low values of relative humidity. Note, for example, that yellow dyes fade four times faster at 60 percent RH than they do at 15 percent. However, storage at 15 percent RH is not recommended, because films become brittle and in any case this value is not easy to achieve and maintain in ordinary circumstances. Storage at 60 percent is also not recommended because of the possibility of fungus growth on the film and the fact that packaging materials may be

damaged by long exposure to excessive dampness. All things considered, the most appropriate relative humidity is between 25 and 30 percent.

Effect of Humidity on Yellow Dye Fading (temperature range 13 to 32°C)

Relative Humidity	Relative Fading Rate	Relative Storage Time
60%	2	1/2
40%	1	1
15%	1/2	2

Contamination: Damage to photographs by atmospheric pollution and various physical hazards are discussed on page 9. This discussion applies equally to black-and-white and color photographs.

OTHER APPROACHES TO THE PERMANENCE OF COLOR IMAGES

An alternative solution to the problem of preserving color images for extended periods is to make black-and-white separation masters—either positive or negative—depending on the form of the original. Since these separations are records in silver of each of the dye layers of a color original, they can be expected to last as long as a properly processed black-and-white photograph stored in the best possible manner. If a color reproduction is required from the separations at some later date, it can be made by a dye imbibition method or by tricolor exposures onto a color photographic material.

Before undertaking the production of many separation sets consider the following: The process is expensive and it entails skilled photographic work, because the density and contrast of each master must be matched carefully by exposure and development to produce a good color reproduction. Moreover the only way to be quite sure that this will be so is to make a sample reproduction in color. This type of check is often omitted because of the high cost. At a minimum, good sensitometric records should be kept if a satisfactory reproduction is expected to be available at some much later date.

If the colors in the original are thought to be unnecessary, consider making a simple black-and-white negative from the original color picture. This is a far less costly procedure than making separation masters and the work is well within the competence of most photographic workers.

Selection of Color Images: Since the cost of special storage facilities, the making of duplicates, and

other kinds of photographic work are costly, custodians should balance these costs against the value they place on the material. Clearly, it's a good idea to reduce the number of photographs in a collection to the smallest amount possible, and so reduce the task of preservation to manageable proportions.

RECENT ADVANCES IN COLOR TECHNOLOGY

Most of the material in this book deals with preserving photographs already in existence. However, some modern color materials, notably KODAK EKTACHROME Films (Process E-6) now have better keeping characteristics than earlier films of the same type. In fact, transparencies made on these films should retain excellent color fidelity for generations under easily attainable *dark* storage conditions. These conditions are 70°F (21°C) or lower coupled with about 40 percent relative humidity. The implication here is that with successive duplication at long intervals, color images can be made to last indefinitely.

A NEW METHOD FOR RESTORING COLOR TRANSPARENCIES

A recently devised method of making restored duplicates from color transparencies that have faded in dark storage promises to provide improved reproductions of faded material. When the restored duplicates are made on KODAK EKTACHROME Duplicating Film 6121 or on KODAK EKTACHROME Slide Duplicating Film 5071, the restorations can be expected to retain excellent color fidelity for generations. Thus, historically important images that are beginning to fade can be restored and kept indefinitely.

Since working instructions for this duplicating technique are tentative, they are not published here, but are available from Eastman Kodak Company, Customer Technical Services, Rochester, New York 14650.

REMOVAL OF PHOTOGRAPHS FROM COLD STORAGE

Warm-Up Time: To prevent moisture condensation on material taken from a refrigerator or freezer, the package must be allowed to reach equilibrium with the room temperature before being opened. The warm-up time required depends on the temperature differential between the photographs and the ambient air, the dew point of the air, the quantity of photographs, and the size and insulation of the packaging.

Since warm-up time recommendations cannot be given for all the different conditions that might be encountered, a practical test should be made for the particular conditions. Moisture condensation is not only harmful in itself, but also might lead to subsequent return of the photographs to storage in a high-moisture condition. Bear in mind that photographs should be resealed in equilibrium with low RH before being replaced in cold storage.

Photographic Collections

Ideally, collections of photographs should be organized and stored in such a way as to permit easy retrieval at any time and to permit periodic inspections of the material to make certain that deterioration has not begun to occur. These objectives can best be accomplished if planned for when a photographic collection, a series of projects, a photographic department, or an archival record is initiated. When existing, unorganized collections are involved, greater effort may be required.

A collection of photographs may contain black-and-white negatives and prints, and color negatives, prints, and transparencies. Collections contributed to museums, libraries, and archives may also contain prints in a variety of sizes, mounted or un-mounted, packed in envelopes or boxes, or even framed. Such collections may be in good condition or contain evidence of deterioration and damage.

BASIC CONSIDERATIONS

Scope of Collection. A thorough understanding and recognition of the purpose and significance of a collection is necessary to permit realistic planning for a practical and useful archive. Any new collection should be considered with respect to subject specialization, the number of possible projects, the coordination of projects into a coherent collection, and the likelihood of future expansion. Contributed collections must be carefully studied with reference to content, significance of the content, and integration into existing historical archives, if any.

Space and Equipment Requirements. When the purposes and contents of a collection are thoroughly established, the space required to house the collection must be estimated. This estimate, of necessity, involves a determination of the filing system and equipment to be used, as well as decisions pertaining to control of temperature, relative humidity, etc. (See "Storage Conditions" and "Air Conditioning," on pages 23 and 28, respectively.) A controlled atmosphere in the storage area is probably the most important protective measure. If a restoration area is required, it should be located away from the proposed storage area.

Tintype.
Courtesy of International Museum of Photography.

Proposed Staff. Once the decision has been made to file and store a collection, the selected filing system should be implemented from the first and practiced regularly as materials are prepared and identified. If retrieval and service to the public are important, this operation should become as routine as any other photographic operation. The procedure to be implemented should indicate the work hours required per day or over any other time period and, therefore, the number of persons needed to accomplish the proposed task.

Financial Planning. When the proposed budget, based on the estimated costs of space, equipment, supplies, and personnel, is considered relative to available financial support, some important questions and decisions may arise.

In the case of a proposed new collection, some compromise may be necessary, such as pursuing a unit part of the long-range plan. In the case of a contributed collection, a preliminary general sorting of the material can be made; the collection can then be placed in temporary storage containers appropriately identified but without filing or cataloging. When time becomes available, the classification can proceed in greater detail.

FILING

Filing systems, to be effective, must satisfy two basic requirements. First, they must provide for the secure storage of the negatives, so that they will be as free as possible from the damaging effects of dust, finger marks, scratches, and age. Second, they must be arranged systematically according to an easily comprehended classification scheme that will facilitate the prompt location of any article. These requirements apply equally to color transparencies mounted as slides or unmounted but enclosed in KODAK Sleeves. They also apply to prints, especially in those cases where no negative exists, as in many historical collections.

Before negatives or transparencies are consigned to a central file, the classification system must be set up so that the retrieval of any item will be definite and fairly obvious, i.e., the chain of thought that originally places the negative in its position in the file must be straightforward enough to be duplicated by anyone searching the files for the same item at a later date.

Subject Name. There are many classification systems that will suggest themselves to suit the types of work being done by individual photographic organizations. For the commercial photographer, the name of the subject or client serves as the best filing key, and alphabetical sequence in the file is usually all that is required. This same self-indexing method is useful to all photographers whose subjects are almost exclusively human, such as police-identification, industrial-personnel, passport, and medical photographers.

Job Name or Number. Commercial illustrators and industrial photographers, on the other hand, are not so concerned with individuals as with jobs or products, and for them filing by product name, company, or department, job name or number, or even part or style number is a desirable system. It is only necessary to decide which attribute of the majority of the work will best serve to identify it. Thus, if product name is used as the file key, it is imperative that each negative be correctly identified by its accurate product name. If job order, part, or style number is the chosen key, then filing should be in numerical sequence. Within classification divisions under one name or number, it is convenient to keep the material in chronological sequence in the order in which it is made.

Accession or File Number. If the character of the photographic work is widely diversified or cannot be anticipated well enough to decide between a numerical and an alphabetical system, or if neither system will fit a large portion of the work, then it is necessary to resort to a chronological accession sequence or a "file number" system. In this type of file, all negatives are filed in the order in which they are acquired, regardless of subject, and they are assigned file numbers denoting their file locations. Since these numbers are descriptive of file position only and have no bearing on the subject matter, an index and possibly cross-indexes are required.

The master index can be simply an entry log arranged by file numbers and dates in the same order as the negatives in the file. Cross-indexes can be made up by subject name, number, or any other scheme by which the photographs can be described adequately. Naturally, as will be discussed later, a file number must be placed on each negative and print.

This system allows the location of any negative through its file number by one of three possible identifying factors: (a) from the file number on an available print; (b) by scanning the accession file in the region of the approximate date; and (c) from the cross-index by subject name, part number, geographic location, etc. The flexibility of this system is obvious, since any new subject category can be entered by use of a new cross-index.

A uniform filing system is not always possible, especially in the case of some acquired collections, which may consist of a mixture of negatives, prints, and transparencies in a variety of forms. Such collections may be very valuable and usually should be protected from public browsing. Each type of photograph should be filed in its own cabinet and keyed to a numerical accession file with an appropriate cross-index.

Often historical prints vary in size; may be unmounted or mounted; may be framed; and may require restoration treatments or copying prior to filing. Special storage arrangements may be involved for parts of some collections.

A master file index utilizing catalog cards may be the most practical approach. All nonstandard size originals can be reduced or enlarged to a standard size, e.g., 10.1 x 12.7 cm (4 x 5 inches) or 35 mm. Framed pictures can be copied and printed to file size or catalog card size. The catalog print is then mounted onto a file card large enough to permit at least 50 percent of the area for suitable descriptive data, e.g., mount a 10.1 x 12.7 cm (4 x 5-inch) print on a 12.7 x 20.3-cm (5 x 8-inch) card.

A Typical File Number and Its Interpretation. An example of a typical file number and its interpretation might be as follows:

77-561-9

The first two digits indicate the year in which the negative was made and serve as a key not only to location but to the negative review and retention program to be discussed later. Five hundred sixty-one, the accession group number assigned serially from the master log, is the same for a whole group of photographs taken at the same time of the same general subject. The last number (9) is the individual negative serial number within group 561. Letter designations (A, B, C, etc) are sometimes used instead of numbers to indicate individual negatives within a group.

Other coding systems can be used to suit individual filing problems. For instance, a letter can be inserted in the notation to designate negative size or file drawer, if different film sizes are kept in different drawers. Or if 35-mm film is filed in rolls, separate from the other film sizes, each frame can be identified by a letter designation for the roll, followed by a frame number, thus:

BXT-23

Between "A" and "ZZZ" in this system, over seven- teen thousand rolls can be described, while extension of the system to "ZZZZ" will accommodate almost a half million rolls.

Identifying Negatives and Prints. Regardless of the negative classification system used, it is good practice to identify each negative, negative envelope, and print. Identification of the negative is of crucial importance, for if the enclosure is lost, destroyed, or rendered illegible, the negative may become useless unless it is of some clearly recognizable subject. If negatives are important enough to preserve, they are important enough to justify careful, consistent effort to provide permanent identification.

Since photographs are usually made in groups, it is effective to assign a number or name to each group, and a sequence number to each individual negative within that group, as described in the preceding section. Thus, in the subject-type classification, the name used in filing can be abbreviated and followed by a number indicating the particular exposure. If a numerical system is used, the characteristic notation should be the accession or job number, followed by a sequence number on negatives and prints. The group accession number needs to be written only once on each strip of exposure, but each frame should be identified with its individual sequence number or letter. Of course, every sheet-film negative and every frame of roll film that has been cut apart from adjacent frames should be identified in full.

The file number should be placed in an upper corner of each file envelope—oriented with regard to its filing position—and the same number should be marked with India ink in the clear marginal area on the back of the enclosed negative. This expedites the return of each negative to the correct envelope after it has been removed for printing. The reason for putting the notation on the base side of the negative is that the number then prints correctly if unmasked contact proof prints are made.

By the same reasoning, duplicate negatives that have been made on a reversal material, such as KODAK Professional Direct Duplicating Film SO-015, should be numbered on the emulsion side as a guide to proper left-to-right orientation when they are printed. If they are printed with the emulsion toward the print material, as happens if the code notch is used as a guide, the printed image will be laterally reversed.

It is best not to write complete data for each negative on the face of the negative container, since

this leads to duplication of information that actually needs to be written only once on the index card or group enclosure. There is also a possibility that some inks used for the purpose may strike through the paper and eventually cause disfigurement of the negative.

For some applications, the file number can be written within the exposed area of one corner of the negative, and it will thus print automatically on the face of prints made thereafter. This idea is sometimes useful for service-type pictures, but it must be used with discretion to prevent marring a useful area of the scene, and it should not be used where future publication is anticipated.

If it is necessary that the file number or a caption and file number be printed photographically on the face of the print, a line-copy negative can be prepared from printed or typed material and bound at the edge of the negative for simultaneous contact printing. If enlargements are made, the line copy can be double-printed with the copy negative on a contact printer after the enlarging exposure has been made. Another approach to this result is the use of photographically opaque stencil material that can be cut with a typewriter. The resulting stencil can be used in the same manner as a line-copy negative.

NOTE: In historical collections, it will usually be found that identification within the image area is on the base side of the film. When the information appears in the border area, it may be on either side of the film, depending on which side held the ink better or some other consideration. If the identification is on the emulsion side of an original negative,

Since names and dates are often forgotten, always write such details on the backs of prints. This illustration shows the front and back of a cabinet portrait. Interesting names and dates were carefully noted on the back of the mount.

there is danger that the person printing the negative may position it so that the identification would read correctly if included on the print or enlargement but the image is reversed from left to right.

To prevent such inaccuracy in prints, the proper orientation of the negative should be checked, if possible. Internal indications in the image or in other negatives belonging to the same grouping may prove helpful. If the identification would indeed print correctly with the image reversed from left to right, a legend such as "PRINT TO READ OK" can be put along the edge of the negative as a guide to anyone printing the negative at a later time.

Prints are most simply identified by a penciled file letter or number on the back. This designation can be picked up from the negative as it is inserted in the printer or enlarger, and transcribed by the operator with a soft pencil *at one edge* on the back of the print either before or after the exposure is made and before the processing begins. After the print is washed and dried, this number can be dressed up by using a rubber stamp showing the company or photographer's name, the date, and a box or line embracing the file number.

File Retention Programs. Photographic files may become rather bulky and require more space than is justified unless documentary considerations are of prime importance, and in these cases, separate archival dead-storage should be provided. The active commercial negative file should be kept free of the deadwood of discontinued projects, completed jobs, and outdated products by a continuing program of negative review. One way of accomplishing this end is to establish a practice of each week or month removing and screening all of the negatives that have become two, three, or four years old. Naturally, careful scanning of all negatives before they are filed will eliminate much useless

material by keeping it out of the file entirely. Almost every assignment will have several duplicates and poorly exposed or poorly framed negatives that will never be used, and these are best discarded immediately to prevent their taking up space in the files.

Screening can be done by the head of the photographic department, but it is preferable that it be turned over to the department or person who ordered the work originally. It should be explained that all photographs needed for purposes of record or possible future use should be separated and returned to the file. All discards should also be returned, but they should be marked for disposal. It is important that negatives intended for destruction be returned to the photographic department for final disposition. This routing gives the photographers an opportunity to see what is being destroyed and may save time that would otherwise be spent looking for a negative that is no longer filed. It also allows a note to be made in the accession log as to which negatives have been destroyed and by whose authority.

Disposal of negatives by the photographic department also assures that the negatives are not retained loose in a desk drawer, subject to dust and mishandling, and then later brought out in poor condition for reprinting. At the same time, it prevents negatives falling into unauthorized hands where their future use could not be controlled. Furthermore, the accumulation of discarded black-and-white negatives and prints at a central point increases the likelihood that silver recovery from the scrap will be economically feasible.

Collections donated to museums, art galleries, and libraries often consist of hundreds of thousands of pieces. Such collections should be reduced to manageable proportions by careful selection of the best and most meaningful material. Otherwise, deterioration will continue unchecked and the whole accumulation of pictures may be lost by default.

PERIODIC INSPECTION

Most of the deterioration that can be observed in collections of photographs is the result of failure to make periodic inspections of the material. In storing negatives and prints it is not sufficient to provide good environmental conditions and then to leave the material alone for a number of years in the hope that all is well. There is no substitute for some kind of checking for deterioration at regular intervals. In this way, any degrading effects that may be taking place will be seen in time for corrective action to be taken.

Small collections of photographs consisting of a few thousand items can be checked in their entirety in a reasonable time. Larger collections that consist of hundreds of thousands of items must usually be checked by a sampling method, unless continuous inspection is possible.

One method of sampling is to take a few negatives or prints at random from the various containers, such as drawers or cabinets, and to examine the material thus collected for deterioration. This system is better than none, but it may leave many areas unexamined. A more efficient system, such as the following, is suggested. Break the collection down into groups distinguished by essential differences, such as size, kind of film, origin of the material, and age, sampling, say, 5 out of 100 items in each group. Collections filed numerically as a consecutive whole can be sampled similarly.

With new material, inspection should be carried out at two-year intervals until the material is about eight years old. If no deterioration is observed in that time, the intervals can be extended to three years. Older material can be examined every five years; if deterioration has not set in after, say, twenty years, it is unlikely to do so during the next five years.

This checking system should reveal any general deterioration that may be taking place, but it cannot locate, except by chance, isolated incidences of trouble. These can be located only by examining the whole collection, a procedure that is not feasible if the collection is a large one.

EXAMINATION OF SAMPLES

When samples are taken from their drawers or other containers, make sure to mark them so that they can be returned to the same position or to the same sequence from which they were taken. Examine negatives carefully over an illuminator, and note if any overall yellow stain is forming as compared with a freshly processed negative. Also, look for uneven brownish stains in the silver image. Silver sulfide stain often develops on old negatives and is particularly prevalent on old glass plates. This is a grayish stain with a metallic sheen when viewed by reflected light, which appears brown by transmitted light. See "Silver Sulfide and Silver Stains," on page 52. Deterioration found on negatives can usually be arrested by suitable treatment, which in most cases is simply cleaning, refixing, and washing.

In examining paper prints, look for overall yellowing of highlights and print borders. Examine the image for brownish yellow discoloration, which indicates deterioration caused by residual hypo or some other oxidizing agent. Fairly recent unmounted prints can be bleached and redeveloped to eliminate much of the stain in the silver image. Overall yellowing can be arrested by refixing and washing. However, mounted prints and very old prints may be destroyed by such treatment. The most reliable method of preserving the images is to copy the print and make fresh prints from the copy negative. See "Copying Prints," on page 49.

Duplicating and Copying

This section outlines photographic procedures for preparing second-generation images that can be processed for maximum stability. In the course of making photographic copies, defects that impair the usefulness of original images can be reduced or eliminated.

Here it is necessary to take note of the copying work, usually known as "restoration," offered by many professional photographers, who either do the work themselves or send it out to specialists. By this means, the public is offered copies, miniatures, or even oil paintings from old and damaged family portraits, wedding pictures, or other photographs of sentimental value. Besides copying to the desired size, such work frequently includes spotting, etch-

This old, faded print was copied on a blue-sensitive film and developed for high contrast. The dark area in the center was caused by a yellow stain on the original print.

In this reproduction, the stain was eliminated by making the copy negative on KODAK Contrast Process Pan Film 4155 (ESTAR Thick Base) with a yellow filter over the lens.

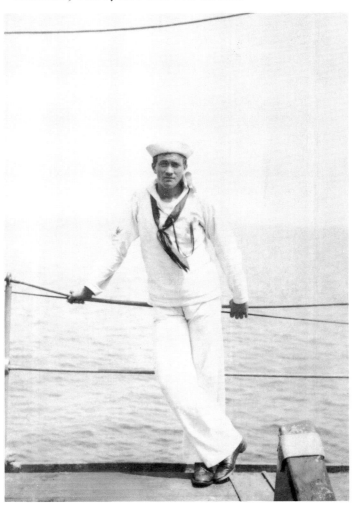

ing, pencil work, and air brushing to repair cracks and soiled areas, reconstruct missing portions, and remove figures or details. As a rule, custodians of photographic collections do not make use of these services, because the cost of the photographic work and hand finishing is high. Another consideration is that artwork, however skillfully it may be accomplished, tends to detract from the authenticity of an original image.

Normal duplicating and copying, on the other hand, are not intrinsically difficult. Although experience is helpful, as in many kinds of photographic work, the procedures are basically simple and inexpensive.

PHOTOGRAPHIC STAIN REMOVAL

The chemical methods of stain removal described in the following section entail some risk of further damage to the original. Therefore, before any attempt is made to remove a stain chemically from a negative or print, it is essential to make a photographic copy of the original. In the process, the effect of the stain can often be reduced or even eliminated.

The basic principle is to use, with a panchromatic film, a filter of the same color as the stain. Thus a yellow filter should be used for a yellow stain, and so on. With a suitable filter, almost any colored stain can be removed, provided it is not muddy, as if it had been mixed with a black medium. It is simply necessary to choose a filter that makes the stain disappear when viewed through the filter.

When the stain contains some gray or black, this method is less effective, and it may be necessary to resort to a chemical or physical treatment. Even then, making the best possible protection copy of the original requires use of a filter, because the filter will at least reduce the effect of the stain.

KODAK Separation Negative Film 4131, Type 1, is recommended for making interpositives from stained negatives. The following filters will be found useful:

Stain Color	Filter Color	KODAK WRATTEN Filter No.	Filter Factor (Tungsten)
Yellow	Yellow	15	1.5
Red, amber, orange	Red	25	4
Green	Green	58	8
Blue-green, blue	Blue	47	20

Use a speed of ASA 64 for the film without a filter, and multiply the exposure by the factor shown in the table. Aiming for a highlight density of about 0.40, develop the interpositive in KODAK Developer DK-50, which is available in prepared powder form. Using the developer without dilution, develop for 4 minutes in a tray with constant agitation at 20°C (68°F). If the exposure was made through the No. 47 Filter, increase the time to 4½ minutes.

If the interpositive is printed by projection in an enlarger or copying camera, the filter can be used over the lens. In this case, a piece of filter only slightly larger than the lens mount is required.

The same film, with the same procedure but without a filter, can be used to make the duplicate negative. Process in the same way, but expose for a shadow density of about 0.30. When making either an interpositive or a duplicate negative, take care to give sufficient exposure for full detail in even the clearest parts of the image. A good duplicate negative has no clear shadows.

Since panchromatic sensitivity is not needed, KODAK Commercial Film 6127 and 4127 (ESTAR Thick Base) is more economical for making duplicate negatives. Using KODAK Developer DK-50 without dilution, develop for 8 minutes in a tray with constant agitation at 20°C (68°F).

The developing times given in this subsection are starting points for interpositives exposed in a camera, diffusion contact printer, or diffusion enlarger. If you are using a condenser enlarger, decrease the developing time by about 15 percent.

DUPLICATING NEGATIVES

Black-and-white negatives that are free from local stains can be duplicated by a relatively simple process that yields duplicates comparable in quality and sharpness to the originals. Designed for the purpose, KODAK Professional Direct Duplicating Film SO-015 (ESTAR Thick Base) yields duplicates in sheet form with one exposure and simple development. Note, however, that the image on a direct duplicate negative that has been exposed emulsion-to-emulsion will be reversed from left to right.

Since the emulsion of the direct duplicating film is necessarily somewhat slow, the film is best exposed by contact. The film can be developed in a tray with KODAK DEKTOL Developer (diluted 1:1) for 2¼ minutes at 21°C (70°F) or in a tank with KODAK Developer DK-50 (full strength) for 5 minutes at 21°C (70°F). The duplicating film can also be

processed in one of the KODAK VERSAMAT Film Processors. Although exposure by contact printing is the easiest method of producing the duplicate negatives, they can also be exposed by projection in an enlarger. This method is sometimes necessary if good contact cannot be obtained with buckled negatives. Buckling is sometimes caused by subjecting negatives to excessive heat, but with old negatives it may be caused by shrinkage or deterioration of the film base. Nitrate base in an advanced stage of decomposition is always affected in this way. Exposure by projection is also necessary, of course, if the duplicates must be smaller or larger than the originals. However, high degrees of enlargement are not recommended because of the long exposures involved.

Nitrate Base Negatives.

Nitrate Base Negatives. Most negatives on nitrate film base, particularly those on thin roll-film base, present little problem in duplication, except that many of them have a heavy yellow discoloration, which increases the exposure required. Very old negatives, especially those on thick sheet-film base, are often buckled, and therefore cannot be exposed by contact. Moreover, these negatives may be so brittle that they may break up under the pressure needed for good contact. Consequently, they must be exposed by projection in an enlarger or photographed with a camera by the light transmitted when the negative is placed on an illuminator of some kind. The use of an enlarger is preferable, because the exposure will usually be shorter. Modern enlargers designed for color printing have more powerful illumination than the older ones intended for black-and-white printing. Consequently, if a modern type of enlarger is available, it should be used for making the duplicates. In any case, make sure that the enlarger has an efficient heat-absorbing glass in the system and that the cooling blowers, if any, are working properly.

Sometimes, the gelatin of nitrate-base negatives has become sticky if decomposition is in an advanced stage. This happens most often when the negatives have been stored in batches in a closed, airtight container. Before duplicating negatives that are in a tacky condition, spread them out on a table in a dry atmosphere for about an hour, or until they can be handled. This amount of drying will generally prevent the gelatin from sticking to the emulsion surface of the duplicating film or to the glasses in the negative carrier of the enlarger. Handle negatives that are in advanced stages of decomposition very carefully, because they may be brittle enough to break very easily.

Identification of Duplicate Negatives. When a considerable number of duplicate negatives are being made, it is important to have some positive and simple method of identifying the duplicates with the corresponding originals. If a negative number appears on the clear margin of the original, that number can be printed automatically on duplicates made by contact. Very often, however, the number, or perhaps a legend, appears only on the negative envelope. If the envelope bears a number, it should be printed with india ink on the margin of the original. If the envelope bears only some descriptive wording, assign a number to each negative and record that (with attention to legibility) on both the envelope and the negative. Then, it will be a simple matter to match the originals with the duplicates.

Cracked or Broken Glass Plates. If the glass plate is merely cracked, tape it to a piece of clean glass. If the plate is broken into several pieces, bind it between two sheets of glass.

If the original plate is a negative, put it in a diffusion enlarger and make a print on a smooth, lustre paper. Retouch white or light spots or streaks to match the surrounding image tones; then make a copy negative.

If the original is a glass positive—8.3 x 10.2-cm (an old 3¼ by 4-inch) lantern slide, for example—make an enlarged negative from it in an enlarger. KODAK Commercial Film is a suitable material for this purpose. Retouch the negative to match light spots or streaks into the surrounding image tones; then make prints as required.

COPYING PRINTS

Copying, or rephotographing, prints has often been regarded as a process that yields results somewhat inferior in quality to the originals. A number of years ago, this was true in most cases, but today films are available that are designed specially for copying, and properly used, these materials yield results that compare favorably with the original prints. KODAK Professional Copy Film 4125 (ESTAR Thick Base) can be used to obtain the increased highlight contrast needed in continuous-tone copy negatives. Thus if a print is unique and consequently valuable, a facsimile copy can be made for exhibition or frequent examination while the original is preserved intact.

A more important application for photographic copying is, perhaps, in the restoration of old, faded,

Some information can often be obtained from a badly faded print by copying it with a high contrast, continuous-tone film and then developing the negative to yield the best contrast.

or stained originals whose condition can only become worse with time. In copying the best quality prints, there may be a slight loss of quality, however carefully the work is done, but the results obtained from faded or yellowed originals by copying are often far superior to the originals. Thus, images that might be regarded as practically lost can be given a new lease on life.

Detailed instructions on copying all the different kinds and conditions of original prints are outside the scope of this book. However, all the information necessary for making good copy negatives and good prints from the negatives is contained in the Kodak Data Books *Copying* (M-1) and *KODAK B/W Photographic Papers* (G-1), sold by photo dealers.

Stain Removal

Any treatment of a negative or print with chemical solutions involves some danger of damaging or even completely ruining the image. Therefore, the first and most important rule is: *Always make a photographic copy before subjecting an original to chemical treatment.*

In some cases, it may be possible to eliminate the defect photographically by the use of filters in making a copy negative or print; see "Photographic Stain Removal," page 48. If the original negative is available, it is generally much easier and more satisfactory to make a new print rather than to attempt to restore a faded or stained print.

Before a photographer accepts a job involving chemical treatment of a stained negative or print, he should make sure that the owner understands the risk involved. A photographer who offers independent services should get an agreement, in writing, that the owner accepts this risk.

CAUTION: The following treatments for negatives and prints apply only to gelatin-silver bromide or gelatin-silver chloride materials. Old photographs, such as collodion wetplate negatives, daguerreotypes, tintypes, ambrotypes, prints on albumen papers, or any other photographs of unknown character should not receive any chemical treatment, nor should they be soaked in water, unless a practical test on a similar and expendable subject has been made. Note that daguerreotypes can be cleaned and improved by the special treatment described on page 58.

CLEANING NEGATIVES

Negatives submitted for cleaning are likely to carry a considerable amount of surface dirt, which may consist of processing scum plus fingerprints and dirt picked up in later handling. Very often, too, the emulsion surface has been scratched and abraded by careless handling. Although the following procedure does involve some risk of damage, it has been found to be quite effective with the majority of such negatives. It is suggested only for negatives on acetate or polyester base; see the caution above.

Fungus is frequently present on negatives that have been stored in damp places. If the growth is slight and confined to the surface, it may not cause any problem. If, however, the fungus has invaded the emulsion, it probably has caused the gelatin to become soluble in water. A negative that has been damaged in this way cannot be treated successfully in any aqueous solution, not even a hardener.

In some cases the gelatin may be soft for a reason other than fungus damage. If possible, an expendable area of negative should be pretested with water. If the gelatin is found to be soft, it may be best to omit step 1 and go directly to step 2.

1. First soak the negative thoroughly in clean water, and while it is under water, swab the surface with a wad of soft cotton. In some cases, this will be all the treatment that is needed.

2. If swabbing with water does not remove the deposits, harden the negative in KODAK Special Hardener SH-1 (see "Formulas," on page 54) and rinse it thoroughly.

3. Support the negative on a sheet of glass and swab the surfaces carefully with a wad of cotton soaked in a 5 percent solution of sulfuric acid. To reduce the danger of damaging the emulsion, make sure that the temperatures of the wash water and the acid solution are not above 21°C (70°F).

CAUTION: Always add sulfuric acid to a considerable quantity of water. *Never add the water to acid.*

4. Rinse the negative thoroughly to remove the acid, refix it in a fresh acid hardening fixing bath, wash it thoroughly, and dry it.

This treatment will usually clean off the surface deposits. In addition, the slight softening and swelling of the gelatin will tend to fill in or smooth out shallow scratches and surface abrasions.

CLEANING TRANSPARENCIES

Black-and-white and color positive transparencies (such as KODACHROME and EKTACHROME slides) may be scratched or dirty or show fingerprints, and may need cleaning. The films should be removed from their holders and the holders discarded. They should then be cleaned by wiping with soft plush or absorbent cotton moistened sparingly with KODAK Film Cleaner.

Kodak processing laboratories stopped lacquering KODACHROME transparencies in 1970. If color films need protection from fingerprints, light scratches, and fungus growth, apply KODAK Film Lacquer, or equivalent, as directed on the label. A lacquered surface is more readily cleaned, and in cases of minor damage it is possible to restore the surface by removing the old lacquer and applying new. Most lacquers can be removed by either of the following methods. (If there is fungus growth on the film, use the second method.)

Method No. 1—Sodium Bicarbonate Solution. Dissolve a level tablespoon of sodium bicarbonate (baking soda) in 240 mL (about 8 fluidounces) of room-temperature water. (If used for KODACHROME transparencies, add 15 mL [½ fluidounce] of formaldehyde, 37 percent solution.) Agitate a transparency for 1 minute, or a color negative for 4 minutes. Rinse for 1 minute in room-temperature water. Bathe the film for about 30 seconds in KODAK PHOTO-FLO Solution (diluted as stated on the bottle) and hang it up to dry in a dust-free place. When the film is completely dry it can be relacquered. Apply KODAK Film Lacquer as directed on the label.

Method No. 2—Ammonia-Alcohol Solution. Add 15 mL (about a tablespoon) of nondetergent household ammonia to 240 mL (about 8 fluidounces) of denatured alcohol. Use shellac-thinning alcohol. Agitate the film in the solution for no longer than 2 minutes at room temperature. Longer times may change the color in areas of minimum density. Hang the film up to dry.

An effective way to clean slides on a large scale is to use an ultrasonic cleaner of the type sold for cleaning such things as small metal parts and surgical and dental instruments. A cleaner of 1-pint capacity should be adequate for cleaning slides individually.

SILVER SULFIDE AND SILVER STAINS

Silver sulfide stains are usually seen in three forms: an overall yellowish discoloration, a brownish discoloration of the silver image, or patchy brown stains in the image. Silver stain appears most often around the edges of old negatives and is largely a surface deposit. It is known as "dichroic" stain because it appears gray or metallic by reflected light but yellow or occasionally red or greenish-to-brown by transmitted light. These stains can sometimes be removed or reduced by *careful* use of an ammonium thiosulfate fixing bath with the acidity increased by means of citric acid.

The bath has a preferential action on the stain, but it also attacks the silver image. Take care that the silver image is not reduced to an appreciable extent unless the negative is so dense that some reduction would be advantageous. The printing quality of an already thin or underexposed negative might be seriously impaired.

To mix the reducing bath, prepare KODAK Rapid Fixer (Liquid) as directed on the label for fixing films. Then dissolve 30 grams (1 ounce) of KODAK Citric Acid (Anhydrous) in a litre (quart) of the fixer.

This is a typical example of silver stain at the edges of a glass negative. It is unlikely that a stain so extensive as this can be removed successfully by any means.

Treat only one negative at a time in a tray, agitating frequently. As soon as the stain is removed, take the film from the bath and wash it thoroughly. Stop the treatment sooner if the silver image is attacked noticeably or if the gelatin at the edges of the negative starts to lift or frill.

With a valuable negative, it may be wise to adopt a more cautious approach by giving successive short treatments followed by water rinses. When the desired result has been obtained, be sure to wash the negative thoroughly.

Dichroic Stain. In many cases, the silver stain found on old negatives yields to the reducing bath only after prolonged immersion. Since the stain is partially a surface deposit, the time taken to reduce it can be shortened considerably by treating the dry negative with a very fine abrasive compound, such as *DuPont* White Polishing Compound. This preparation is supplied for polishing lacquer automobile finishes and is procurable at stores that carry such materials.

To reduce the stain, rub the dry negative gently with a tuft of cotton to which a small quantity of the polishing compound has been added. This treatment will remove the surface deposit and any dirt that has accumulated on the negative. An underlying yellow-brown stain will probably remain in the gelatin; this can be minimized by use of the reducing bath.

OTHER STAINS ON NEGATIVES

Several types of stains other than silver sulfide and silver can be reduced by the bleach-and-redevelop technique described below. Among the stains that often yield to this treatment are those due to

developer oxidation, to vegetable material in the wash water, and to the effects of dyes, inks, or envelope seams on stored negatives. Many of these stains are yellowish and consequently can be reduced or eliminated by making a copy negative through a yellow filter as described in the preceding section. In any case, a photographic copy for protection should always be made before the chemical treatment is tried.

Before proceeding, test the negative for residual silver (ST-1 Test, page 16). Then, if necessary refix and rewash the negative.

First harden the film by bathing it for 3 minutes in KODAK Special Hardener SH-1 (see "Formulas," page 54); then rinse the negative thoroughly. Without the hardening, the gelatin is likely to soften and frill during the subsequent treatment.

Bleach the negative in KODAK Stain Remover S-6, rinse it thoroughly, and treat it in a 1 percent solution of sodium bisulfite to remove the brown manganese dioxide stain.

Wash the negative for 3 or 4 minutes and expose it to a strong light (sunlight, arc light, or high-intensity tungsten illumination) until the white silver chloride image turns purple.

Redevelop the negative (in full room light) in KODAK DEKTOL Developer (available in prepared powder form) or KODAK Developer D-72 (see "Formulas"), either one diluted 1 part of stock solution to 2 parts of water, or some other active low-sulfite developer. If the bleached image is not exposed to strong light before development, it will redevelop slowly, and a weak, brownish, mottled image may result.

If a slight yellow stain remains after dyes or inks have been treated, it can usually be removed by bathing the film in a 2 percent solution of oxalic acid, followed by washing. Some types of red ink leave a slight trace of stain after the chemical treatment, but this can be removed photographically.

Stains due to envelope seams can often be partially removed by the bleach-and-redevelop technique. However, negatives usually cannot be restored completely by this treatment.

TREATING STAINED AND FADED PRINTS

The removal of stains, or the rejuvenation of a faded image, is often very simple. In some cases, however, it may prove to be a complicated procedure. Chemical treatment is always risky, because the print may be damaged physically or stained worse than it was before the treatment was started. For this reason, copying is recommended over chemical treatment, and in any case a photographic copy should always be made before the treatment is tried. A historically important image is, of course, more valuable as a restored original print than as a copy, but unless a copy is made for protection, there is too much risk of a loss in image quality.

Before doing anything with a print, remove any surface dirt from it by rubbing it with an art-gum eraser or by dabbing it with a piece of soft bread. Remove grease marks with KODAK Film Cleaner. These types of treatment are, of course, unsuitable for black-and-white prints that have been oil-tinted.

Removing Prints from Mounts. Chemical solutions should be applied only to unmounted prints. Prints that have been mounted with thermoplastic or thermosetting adhesive or tissue can sometimes be demounted by heating in a dry mounting press. When the print and mount are hot, the adhesive may be melted sufficiently to allow the two to be separated. However, the print must be peeled off the mount immediately after the press is opened; otherwise it will probably readhere to the mount. If the whole print does not peel off at once, *Teflon* sheeting may be useful to prevent readherence of separated areas while the rest of the print is worked on.

If the heat treatment fails, the only alternative is to soak the mounted print thoroughly in water, then place it face downward on a sheet of smooth paper on a table. Now try to *peel the mount away from the print;* this must usually be done piecemeal and with great care to avoid tearing the print. If an attempt is made to pull the print away from the mount, the print will probably be torn.

This technique is obviously limited to fairly thin mount board. A heavy mount can sometimes be reduced in thickness by slicing off a good part of its bulk with a single-edge razor blade before the print is soaked in water. Another possibility is to soak the print and then split off the mount, layer by layer, with a bone or plastic knife.

Silver Sulfide and Silver Stains. Poorly fixed and inadequately washed prints often develop yellow-brown stains from the decomposition of silver thiosulfates to form silver sulfide. An overall stain of this type or silver stain in the highlights can be treated as follows:

Fix the print thoroughly in plain hypo to remove any residual silver compounds, wash it thoroughly, harden it by bathing it for 5 minutes in KODAK Special Hardener SH-1 (see "Formulas," below), and wash it.

Prepare a reducing bath by mixing KODAK Rapid Fixer (liquid) as directed on the label for fixing films. Then dissolve 30 grams (1 ounce) of KODAK Citric Acid (Anhydrous) in a litre (quart) of the fixer. Treat one print at a time in this solution and remove it as soon as the stain disappears or if the solution begins to attack the image visibly. Then treat the print with KODAK Hypo Clearing Agent solution prepared according to the package label and wash it thoroughly.

Yellow (Iodide) Stains on Glossy Prints. Old glossy prints with deep lemon-yellow stains were probably developed in a solution containing potassium iodide. Although seldom used today, potassium iodide was sometimes added to developers to help prevent abrasion on glossy prints. Potassium iodide converts the surface layer of a silver bromide emulsion to silver iodide, which is deep lemon-yellow, fixes much more slowly than silver bromide, and does not darken on exposure to light.

These lemon-yellow iodide stains can usually be removed completely by bathing the print in a fresh fixing bath. Some paper emulsions, particularly those of high contrast, may retain a yellow color during fixing; this will *usually* disappear on normal washing, however.

Faded Prints. Old prints often show yellow discoloration or toning of the lowest densities of the image. This change, first noticeable in the highlights, and popularly known as "fading" because the image becomes less visible, is produced by the action of thiosulfate on the silver image to form yellowish silver sulfide. Often a bronzing or mirroring of the maximum density areas is noted. The finer the grain of the image, the more readily it is attacked. Thus prints, which have very fine-grain images, fade much more readily than negatives.

If the image is faded but there are no highlight stains, bleaching and redeveloping may restore the print. Note, however, that the procedure is satisfactory only for images on "developing-out" papers. *Gold-toned images on "printing-out" papers are ruined by this treatment*, because the gold image is converted to soluble gold chloride by the bleaching bath.

Unless the print has already been refixed and hardened, fix it thoroughly in plain hypo to remove any residual silver compounds. Then wash it thoroughly, harden it by bathing it for 3 minutes in KODAK Special Hardener SH-1, and wash it for 5 minutes.

Bleach the image in KODAK Stain Remover S-6, rinse the print thoroughly, and treat it in a 1 percent solution of sodium bisulfite to remove the brown manganese dioxide stain.

Wash the print for 3 or 4 minutes and expose it to a strong light (sunlight, arc light, or high-intensity tungsten illumination) until the white silver chloride image turns purple.

Redevelop the print in KODAK DEKTOL Developer (available in prepared powder form) or KODAK Developer D-72 diluted 1 part of stock solution to 2 parts of water.

Faded Images on Printing-Out Papers. Faded prints on printing-out paper that was fixed (not toned) can usually be improved by bleaching in the Special Bleach Bath given at the end of the following subsection, clearing with sodium bisulfite, washing thoroughly, and then redeveloping.

Stained or fogged prints on printing-out paper that was merely printed and not fixed or toned should not be treated chemically. If not too badly stained, they can often be copied successfully on a panchromatic material. Use a yellow filter, such as a KODAK WRATTEN Filter No. 15, over the print to avoid further darkening of the image by the action of light and to increase the contrast of the image.

FORMULAS

KODAK SPECIAL HARDENER SH-1

Water	500	mL
Formaldehyde, about 37% solution		
by weight	10.0 mL	
KODAK Sodium Carbonate		
(Monohydrated)	6.0 g	
Water to make	1.0 L	

Harden the negative (or print) for 3 minutes; then wash it for 5 minutes before it is given any further chemical treatment.

KODAK STAIN REMOVER S-6

Stock Solution A

Potassium Permanganate	5.0 g
Water to make	1.0 L

Stock Solution B

Cold water	500 mL
Sodium Chloride	75.0 g
*Sulfuric Acid (concentrated)	16.0 mL
Water to make	1.0 L

***Caution:** Always add the sulfuric acid to the solution slowly, stirring constantly, and never the solution to the acid; otherwise, the solution may boil and spatter the acid on the hands or face, causing serious burns.

Mix the chemicals in the order given. When mixing Solution A, be sure that all the particles of permanganate are completely dissolved; undissolved particles may produce spots on the negatives.

When you are ready to begin the stain removal procedure, mix equal parts of Solution A and Solution B. This *must* be done immediately prior to use; the solutions do not keep long in combination.

Procedure: Harden the film to be treated for 3 minutes in KODAK Special Hardener SH-1 and wash it for 5 minutes. Mix Solution A and Solution B as directed above, keeping the solutions at 20°C (68°F). Immerse the film in this bleaching solution for 3 or 4 minutes. Next, to remove the brown stain of manganese dioxide formed on the negative in the bleach bath, treat the negative in a 1% sodium bisulfite solution (make a 1% solution by adding 10 grams of sodium bisulfite to 1 litre of water). Wash the negative for 3 or 4 minutes and expose it to a strong light (sunlight, arc light, or high-intensity tungsten light). Redevelop in a nonstaining developer such as KODAK DEKTOL Developer or KODAK Developer D-72 diluted 1:2 with water. Then wash thoroughly.

Caution: Slow-working developers, such as KODAK Developer D-76, KODAK MICRODOL-X Developer, and KODAK Developer DK-20, should not be used, since they tend to dissolve the bleached image before the developing agents are able to act on it.

KODAK DEVELOPER D-72

Stock Solution

Water, about 50°C (125°F)	500 mL
KODAK ELON Developing Agent	3.0 g
KODAK Sodium Sulfite (Anhydrous)	45.0 g
KODAK Hydroquinone	12.0 g
KODAK Sodium Carbonate (Monohydrated)	80.0 g
KODAK Potassium Bromide (Anhydrous)	2.0 g
Water to make	1.0 L

For Use: Dilute 1 part of stock solution with 2 parts of water.

KODAK Dektol Developer is a packaged preparation with similar photographic properties.

Special Bleach Bath For Restoring Faded Prints on Printing-Out Paper

Stock Solution A

Potassium Permanganate	6.0 g
Water to make	1.0 L

Stock Solution B

Water	500 mL
KODALK Balanced Alkali	45.0 g
KODAK Glacial Acetic Acid	48.0 mL
KODAK Potassium Bromide (Anhydrous)	15.0 g
Water to make	1.0 L

For Use: Mix equal parts of Solutions A and B. (See comments under KODAK Stain Remover S-6.) Use at room temperature (approximately 21°C [70°F]).

Procedure: First harden the print in KODAK Special Hardener SH-1 and rinse it thoroughly. Treat the print in the bleach bath for 3 minutes; then rinse it in running water for 15 to 30 seconds. Clear the brown stain by treating the print for about 5 minutes in a solution of sodium bisulfite (30 grams per litre) and wash for about 1 minute. Expose the print to bright sunlight, arc light, or ultraviolet lamp for about 2 minutes, and redevelop for about 3 minutes in KODAK DEKTOL Developer or KODAK Developer D-72 (diluted 1 to 2), to which KODAK Anti-Fog, No. 1, has been added in the proportion of 6 tablets, or 90 mL of 0.2 percent solution, per litre of diluted developer. After redevelopment, immerse the print in an acid stop bath for 2 minutes with agitation, wash it in running water for 5 minutes, swab the surface carefully, and dry it without heat, preferably without anything touching the emulsion surface.

Appendix

IDENTIFYING OLD PHOTOGRAPHIC MATERIALS

Most collections of old photographs contain some made by processes that were in use before negatives and prints were made on the more recent gelatin-chloride or gelatin-bromide materials. Archivists who are familiar with the history of photography are able to recognize the different types of original. Others may find the following descriptive material helpful. The dates given are in most cases only approximate.

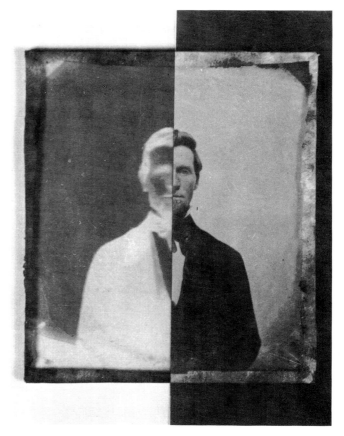

This illustration shows the negative/positive character of the Ambrotype. The black backing has been removed from the left hand side.

Sarah Bernhardt. 1880 albumen print by N. Sarony.

Albumen Paper. Silver image, brown in tone. Prints on this material have quite a smooth surface due to the albumen, of a high lustre but not quite glossy. They are usually discolored with a yellowish brown stain. About 1850 to about 1895.

Ambrotype. A silver-collodion process in which a thin negative is made to appear positive by mounting it against a black background, usually velvet, paper, varnish, or glass. Against a white background, the image is seen as a negative. May in a few cases be laterally reversed, but is not if the image is viewed through the glass on which the collodion film was formed. 1852 to about 1875.

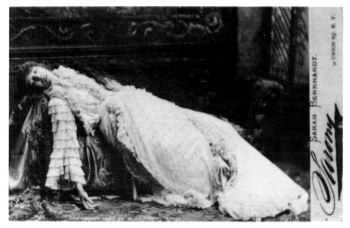

"The Open Door" Callotype
by William Henry Fox Talbot.

Calotype. (Talbotype) Early process for making paper negatives in a camera and paper prints from them, using development. This so-called "salted paper" process involved bathing paper in solutions that would react to deposit sensitive silver salts. The negative paper was usually thin to facilitate printing through it. Sometimes it was also waxed to make it more transparent and minimize the adverse effect of the paper texture on print image quality. Print image brownish, with a tendency to fade to thin yellow. 1841 to about 1855.

Collodion Wet Plate. A glass plate, usually a negative, often showing density variation along the edges, due to uneven coating. The image is typically brownish yellow and highly reflective. Sometimes coated with varnish. About 1851 to about 1880.

Gold-Toned Printing-Out Paper. Prints on this material can be recognized by the purplish image tone.

General Sir High Gough. Daguerreotype, circa 1850, by an unknown English photographer.

Daguerreotype. A high quality image consisting of mercury-silver amalgam on a silvered copper plate, often tarnished with silver sulfide in the same way as silverware; see the following subsection for cleaning instructions. Typically reversed from left to right, though it may not be if the subject was originally photographed in a mirror or through a reversing prism. The image disappears if viewed at the same angle as the illuminating beam. 1839 to about 1855.

"The Orchard" 1902 platinum print by Clarence H. White.

Platinum Prints. Images of metallic platinum, often displaying outstanding tonal range. The prints have excellent permanence. 1875 to early 1900's.

Civil war soldier. Tintype (ferrotype) by an unknown photographer. Circa 1862.

Tintype. (Melainotype, Ferrotype) An image formed by the wet collodion process and giving a grayish silver negative, which appears as a positive on a sheet of black japanned iron (contains no tin). The image is almost always laterally reversed. Sometimes confused with ambrotypes and daguerreotypes, but easily distinguishable from them by the fact that a tintype attracts a small magnet. 1852 to early 1900's.

CLEANING DAGUERREOTYPES

A daguerreotype is a mercury-silver amalgam image on a silvered copper plate. Daguerreotypes are easily distinguished from tintypes, although the two bear a superficial resemblance. An image of silvery character and a copper support indicate the daguerreotype, whereas the tintype is a whitish silver deposit on thin black sheet iron.

Tarnished and dirty daguerreotypes can be cleaned and a great deal of the original character restored by careful cleaning by the method described below. The image is delicate and no form of abrasive cleaner can be used, nor should the surface be touched.

At one time, potassium cyanide was recommended for cleaning, but apart from the fact that potassium cyanide is a deadly poison, it tended to reduce the image as well as remove the silver sulfide tarnish. The following method of treatment has been found to be satisfactory and relatively safe. It is a refinement of an earlier thiourea treatment and was devised by Mrs. Ruth K. Field of the Missouri Historical Society. Note that there is no assurance that the restored image will not undergo later deterioration.

1. Wash the daguerreotype carefully in distilled water to remove surface dirt and any paper that may be adhering to the back of the plate. The temperature of the water should not be higher than 21°C (70°F).

2. Drain the plate and immerse it in this solution:

Distilled water	500	mL
Thiourea	70	g
Phosphoric Acid (85% solution)	80	mL
KODAK PHOTO-FLO Solution	2	mL
Distilled water to make	1	L

WARNING

Thiourea is a potentially dangerous substance. Be sure to acquaint yourself with any necessary handling precautions outlined on the product label.

Do not allow thiourea, or a solution containing thiourea, to come in contact with the skin. Use rubber gloves in preparing and using the solution. Afterward, decontaminate the gloves by rinsing the outer surfaces with a dilute solution of sodium hypochlorite. This solution can be prepared by adding 30 millilitres (1 fluidounce) of Clorox, 101, or similar liquid household bleach to 1 litre (quart) of water. Finally, wash the gloves thoroughly with warm water.

Caution: Thiourea is a powerful foggant of photographic emulsions. Therefore, this solution must not be prepared or used in close proximity to areas where light-sensitive materials or processing chemicals are handled or used.

3. Remove the plate from the bath and hold it under gently running water. Then rinse it in distilled water again.

4. Immerse the plate in 95 percent ethyl (grain) alcohol and drain it. The denatured alcohol sold for thinning shellac is satisfactory for this purpose.

5. Dry the plate in a current of warm air.

The plate can remain in the cleaning solution (step 2) for as long as is necessary to remove the tarnish, but it is suggested that the immersion time be not longer than 20 minutes.

CAUTION: Daguerreotypes are delicate; they should be handled by the edges, and should never be touched with the fingers or wiped in any way.

STORING PHOTOGRAPHS UNDER TROPICAL CONDITIONS

In many parts of the world, excessively hot and damp conditions prevail throughout most of the year. In other places, these conditions prevail for several months each year. High temperature is detrimental to the keeping of unexposed sensitized materials, and high relative humidity is of special concern in the keeping of finished photographs. Consequently, special precautions must be taken to combat the growth of fungus, attack by insects or bacteria, and the hastening of chemical reactions that affect silver images or the dye images of color photographs. Also, under hot and humid conditions, mounts, albums, enclosures, and other packaging materials may disintegrate, and cans made from ferrous metals rust rapidly.

In hot, dry, desert climates, temperature and consequently relative humidity cycle rapidly between very high and comparatively low levels. Abrasive dust is also a problem in very dry climates. These conditions are damaging to photographs and must be guarded against as far as possible.

Processing Under Tropical Conditions. If negatives, prints, and transparencies have been inade-

Warm, humid conditions favor the growth of fungus on the gelatin coating of photographic materials. When the growth becomes established, irreparable damage is caused, as shown by this reproduction of a color slide.

quately prepared in processing, high temperatures and high relative humidities will accelerate the rate of their deterioration. *Careful processing is therefore most important.* Negatives and prints that are to be kept for any length of time in a tropical environment must be as free from residual processing chemicals as it is possible to make them. The essential requirements are fixing for the proper length of time in a fresh fixing bath and sufficient washing and hypo elimination thereafter to remove the last traces of hypo and silver complexes from the material. See "Processing for Stability," on page 9.

If processing is carried out in an air-conditioned room, tropical temperatures will not be a problem, provided the processing solution temperatures can be adjusted to match each other and to be at the recommended level. However, the temperature of the water supply to the building may be considerably higher than that of the processing baths and a water chiller should be installed if softening of gelatin or reticulation of negatives is to be avoided. Units for this purpose are available from manufacturers of processing equipment.

If the building is not air-conditioned, a room air conditioner in the darkroom is recommended. (Perspiration is detrimental to films and papers in a tropical environment.) If no temperature control can be provided, special procedures must be followed, especially the use of a prehardener before development. See Kodak Publication No. C-24, *Notes on Tropical Photography.*

Storage of Negatives and Prints. Clearly, it would not be advisable to keep valuable photographs in a tropical situation without proper air conditioning in the storeroom. In an air-conditioned area, material can be stored in much the same way as in more equable climates. For protection against fungus growth, negatives can be packaged in paper envelopes made from pulp to which fungicide has been added during manufacture.

To treat black-and-white prints for protection against fungus, immerse the prints for 3 to 5 minutes in a 1 percent solution of diisobutyl-cresoxy-ethoxy-ethyl-dimethyl benzylammonium chloride. This chemical is supplied as HYAMINE 1622 by Rohm and Haas Company, Independence Mall West, Philadelphia, Pennsylvania 19106. The temperature of the solution should not be lower than 21°C (70°F). Note that the treatment may produce some discoloration, probably not serious with most papers.

As mentioned earlier, a considerable amount of evidence indicates that prints toned by the hypo-alum method are less susceptible to attack by fungus than are untoned black-and-white prints. See "Print Stability Procedures," on page 18.

The following chemical treatment for black-and-white negatives is very effective, but it *must be used with extreme care.*

When the negatives have been washed, bathe them in a 1 percent solution of zinc fluosilicate and water and dry them without wiping. To promote uniform drying, add 1 part of KODAK PHOTO-FLO Solution to 200 parts of zinc fluosilicate solution. Any residue that remains on the base side of unbacked films can be removed with a damp sponge. *Wash the sponge thoroughly afterwards.*

WARNING

Zinc fluosilicate is an extremely poisonous chemical; its use as described above should be confined to photographic workrooms. It can be fatal if swallowed, even in a dilute solution. Wash the hands and everything else that has

A copy from a hypo-alum toned postcard made in 1908. The image shows little fading and no silver sulfide stain at the edges.

been in contact with zinc fluosilicate thoroughly after each use. Place clearly recognizable poison labels on all containers of the chemical. On no account store zinc fluosilicate, or negatives that have been treated with it, in areas to which children have access.

Note that color negatives, transparencies, and color prints should not be treated with fungicides, because these chemicals cause dye fading.

Using a Desiccant. When a small quantity of photographic material is to be kept for a short time—in transit, for example—in a humid situation, it can be placed in a closed, sealed container with a desiccant, such as silica gel. This substance resembles coarse white sand in appearance; each grain is porous, and like a sponge, it absorbs moisture in considerable quantity. Silica gel is odorless, tasteless, and nonreactive with most common materials. It is sold in bulk by a number of chemical supply houses. Avoid forms that may give rise to dust. Prepared drying units, such as *Davison* Silica Gel Air Dryers, are available. (Write to Davison Chemical Division of W. R. Grace & Co., 10 East Baltimore Street, Baltimore, Maryland 21202, for the name of a local distributor.) These are perforated metal containers holding about 1½ ounces of silica gel, with a color indicator that turns from blue to pink when the desiccant needs reactivation. The dryers are convenient for packaging with a limited number of negatives or other material in a closed container. One *Davison* Air Dryer is sufficient to keep relative humidity at a suitable level in a sealed cubic space about 30 centimeters (1 foot) on a side.

Silica gel lasts indefinitely and can be reactivated by heating to a temperature between 149 and 204°C (300 and 400°F) in a vented oven or over a fire. In this temperature range, ½ hour is sufficient to reactivate small quantities; large quantities require 2 or 3 hours. To prevent reabsorption of moisture, allow the hot silica gel to cool in a closed metal container. Then, if the desiccant is not to be used immediately, seal the container.

TREATING WATER DAMAGE

Recent floods in several parts of the United States caused the loss of, or damage to, several collections of negatives that were of considerable historical value. Probably very few of the custodians had thought of the risk of flood damage, because it had not happened to them before. Actually, floods are

only one potential cause of water damage. A particular threat to photographic files or collections is the water used to extinguish fire.

Further, there is always the possibility of water damage caused by a leaky roof, a damp basement, a burst pipe, or an overflowing sink on an upper floor. In many cases, such a possibility should motivate the custodian to find a safer location for storage.

Wet Films and Plates. Photographic materials that have accidentally been soaked with water are in very serious danger, so the job of rescuing them is urgent. If the films are still wet, or even damp, *keep them wet.* Never allow the materials to dry before attempting to salvage them.

Put the wet materials into plastic containers—plastic garbage cans are fine—and run *cold* water into the containers. Use ice to keep the temperature down. Run additional water into the containers to remove mud if there is any. Then add some formaldehyde to harden the gelatin and to prevent the growth of bacteria. About 15 millilitres of 37 percent solution (by weight) per litre is a suitable concentration. This chemical and keeping the water cold help prevent swelling and softening of the gelatin, which could otherwise be the major cause of damage.

This procedure is only a *temporary* measure. The materials must be attended to further at the earliest possible moment, because wet gelatin will disintegrate in a matter of days even under the conditions described. Also, bear in mind that negatives on nitrate base may have soft gelatin, and hence are particularly vulnerable. If the collection contains nitrate-base negatives, clean and air-dry these first.

Cleanup and Drying. If facilities and manpower to perform the following work are not available, keep the materials wet and get them to a professional or photofinishing laboratory as soon as possible. Since not all laboratories are equipped to handle water damaged films, it is advisable to make arrangements over the phone before taking films in for professional handling.

If it is practical to segregate your most valuable photographs, take care of these first, regardless of who does the work. Salvaging films with professional handling can prove to be expensive, and you may decide to discard some films of lesser value.

After removing wet envelopes or other packaging material, wash the negatives, preferably for about half an hour, to remove any traces of mud, silt, paper, etc. Where necessary, *gently* swab the surfaces under water to remove grit. Prolonged washing is not advisable, particularly if the temperature of the water supply is above 18°C (65°F). *Never* use warm water for washing, because it may cause frilling or even melting of already soft gelatin.

Glass plates are often found in boxes of a dozen or so without envelopes or interleaving of any kind. If this is the case, it may not be possible to separate the negatives without transferring parts of the gelatin film from one plate to another.

Give black-and-white negatives a final rinse in KODAK PHOTO-FLO Solution, diluted as directed on the label and then hang them up to dry naturally. Treat color films in the same way, but if their original processing called for a final stabilization step, they should again be bathed in a suitable stabilizer before drying.

If you have a special problem requiring further advice on handling water-damaged films, call the nearest Kodak processing laboratory, or call Kodak in Rochester at (716) 724-4000.

Prints. Water damaged prints can be treated by the same methods described for films. If possible, they should be stored flat in trays of water until they can be properly washed and dried. Generally speaking, try to salvage only those prints for which negatives are not available and prints that are not badly stained. Prints for which negatives are available can be replaced at a later date.

Color prints may prove very difficult to salvage, especially if the emulsion surfaces have had any opportunity to dry and stick to other surfaces as they did so. It is especially necessary to treat color prints in a final stabilizing bath if one was required in the process by which they were originally made.

This book is addressed to those who own or have charge of negatives and prints from the past. Art galleries, museums, archives, and libraries, as well as scientific, industrial, and private custodians, share similar problems in preserving photographs. In many cases there are needs to repair deterioration that has already taken place, to improve the conditions under which collections are stored, and to work with processors in order to make sure that material currently being added is properly prepared.

Since correct processing is an indispensable element in making pictures that last, this Book is also addressed to all who are concerned with processing.

In recent years, concern over deterioration of photographs has spread and intensified among those who have the responsibility for preserving them. Sharing that concern, Eastman Kodak Company has brought together in "Preservation of Photographs" the best advice it can offer on the subject.

1880 **Kodak** 1980

A 100-year start on tomorrow

Professional and Finishing Markets Division
EASTMAN KODAK COMPANY, ROCHESTER, NEW YORK 14650

Kodak, Eastman, Photo-Flo, Dataguide, Poly-Toner, Estar, Kodachrome, Ektachrome, Kodalk, Dektol, DK-50, D-76, Polycontrast, Versamat, Elon, and Microdol-X are trademarks.

Preservation of Photographs
Kodak Publication No. F-30
CAT 111 3281

Printed in the United States of America
ISBN 0-87985-212-7